Basic
Portrait
TECHNIQUES

edited by
RACHEL WOLF

NORTH LIGHT BOOKS
Cincinnati, Ohio

Basic Portrait Techniques. Copyright © 1994 by North Light Books. Printed and bound in Hong Kong. All rights reserved. No part of this book may be reproduced in any form or by any electronic or mechanical means including information storage and retrieval systems without permission in writing from the publisher, except by a reviewer, who may quote brief passages in a review. Published by North Light Books, an imprint of F&W Publications, Inc., 1507 Dana Avenue, Cincinnati, Ohio 45207. 1-800-289-0963. First edition.

98 97 96 95 94 5 4 3 2 1

Library of Congress Cataloging in Publication Data

Basic portrait techniques / edited by Rachel Wolf.
 p. cm.
 Includes index.
 ISBN 0-89134-552-3 (pbk.)
 1. Portrait painting—Technique. 2. Portrait drawing—Technique. I. Wolf, Rachel.
ND1302.B27 1994
751.4—dc20 93-31301
 CIP

Edited by Rachel Wolf
Designed by Sandy Conopeotis
Cover illustration by Jan Kunz

The material in this compilation appeared in the following previously published North Light Books and appears here by permission of the authors. (The initial page numbers given refer to pages in the original work; page numbers in parentheses refer to pages in this book.)

Clark, Roberta Carter. *How to Paint Living Portraits*, pages 38-41, 72, 74-77, 92-97, 140-143 (pages 24-27, 50-53, 68-73, 110-113). *Painting Vibrant Children's Portraits*, pages 55-58, 78-79, 86-87, 117-119 (pages 42-45, 86-87, 108-109, 65-67).

Dawson, Doug. *Capturing Light & Color With Pastel*, pages 4-5, 19, 20-23, 80-85 (pages 10-11, opposite introduction, 90-93, 58-63).

Katchen, Carole. *Creative Painting With Pastel*, pages 40-41 (pages 88-89).

Kunz, Jan. *Painting Watercolor Portraits That Glow*, pages 8-9, 12, 14-17, 22-25, 48-49, 72, 74-75, 78-79, 83, 84-85, 96-101 (pages 28-29, 16-19, 20-23, 46-47, 32-33, 34-35, 30-31, 94-99).

Kunz, Jan. *Watercolor Techniques: Painting Children's Portraits*, pages 16, 19, 21, 23, 25 (pages 29, 100-103).

Nice, Claudia. *Sketching Your Favorite Subjects in Pen & Ink*, pages 2-3, 126-129 (pages 14-15, 74-77).

Pike, Joyce. *Oil Painting: A Direct Approach*, pages 60-63, 66-67, 70-71, 74-75 (pages 36-39, 116 117, 118-119, 40-41).

Poulin, Bernard. *The Complete Colored Pencil Book*, pages 4, 9-11, 41-43, 106-109, 111 (pages 12, 13, 78-80, 82-85, 81).

Smuskiewicz, Ted. *Oil Painting Step by Step*, pages 19, 35, 37, 121, 122-125, 126-127, 128, 129, 130-131 (pages 48, 56, 57, 49, 104-107, 54-55, 64, acknowledgments page, 114-115).

Sovek, Charles. *Oil Painting: Develop Your Natural Ability*, pages 4-5, 67 (pages 5, 3).

Stine, Al. *Watercolor: Painting Smart*, pages 15-18, 20, 69 (pages 6-8, 9, 2).

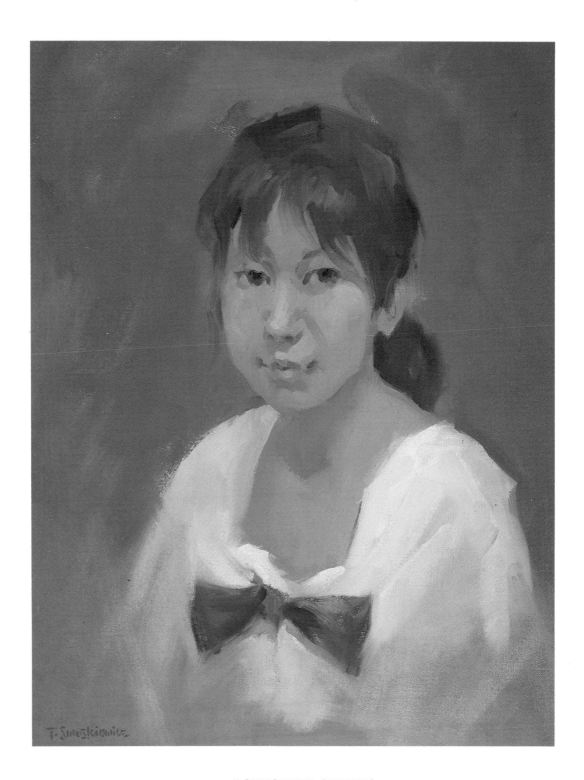

ACKNOWLEDGMENTS

The people who deserve special thanks, and without whom this book would not have been possible, are the artists whose work appears in this book. They are:

Roberta Carter Clark Bernard Poulin
Doug Dawson Ted Smuskiewicz
Jan Kunz Charles Sovek
Claudia Nice Al Stine
Joyce Pike

TABLE
of
CONTENTS

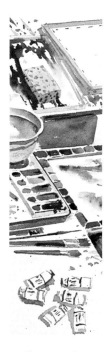

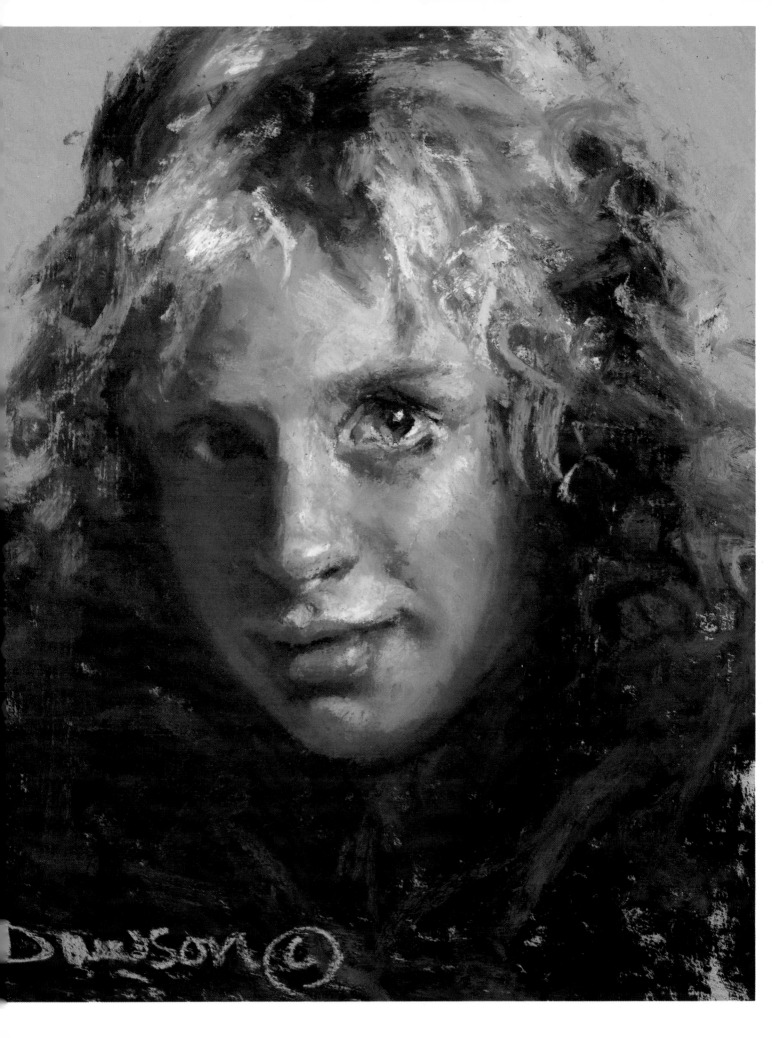

INTRODUCTION

Portraits are among the most exciting and challenging of subjects. They are uniquely satisfying for both the artist and the viewer. Portrait painting may seem difficult—after all, you can't fake a likeness like you may a grouping of trees, and even your subject can offer comments on your efforts. But with practice and careful observation, your efforts will soon produce satisfying results.

This book offers instruction and encouragement to all painters, regardless of the medium the painter prefers. Oil, watercolor, pastel, colored pencil, pen and ink—they're all here.

We have assembled this book from some of the best teaching on portrait painting that's available—everything the beginner needs to get off to a smooth start. In the first chapters, you will find useful information on materials and color, basic facial structure and proportions, painting from live models and photos, and composition techniques. The latter part of the book offers demonstrations in a variety of techniques that will help you tackle some of the most intriguing elements of portrait painting. You'll learn to model the features and explore ways to bring the warm glow of life to your portraits. The only additional ingredients you will need are practice and the knowledge that interest and effort can overcome any lack of the elusive quality we call talent.

Chapter One

BASIC MATERIALS
Everything You'll Need to Get Started

Most painters are fascinated by all the equipment we use for painting. This fascination began with our introduction to painting when we were mystified and confused by all the materials needed. We were impressed with the array of brushes, paints and other paraphernalia that more experienced painters had accumulated. Most of us have since become gadgeteers and collectors who sustain a lifelong habit of picking up anything that might be useful.

Even though we have all the gizmos that most artists keep in their paint boxes or on their studio tables, we rarely use more than one or two of them on any one painting. Instead, we usually stick to the basics. Although it is fun to collect odds and ends for special tricks and effects, there is no magic in them. They won't do your painting for you.

Good painting begins with knowing what the basic tools and equipment will do. Eventually you'll find it easy to choose a special tool for a particular texture or effect. In this section, we'll take a look at the essential tools needed for oil painting, watercolor, pastel, colored pencil, and pen and ink.

In addition to getting the right materials and learning to use them, it is important to set aside a permanent place in your home to work, preferably one where you can retreat to paint undisturbed. Many artists have started their careers on the kitchen table, but having a space dedicated to your art can be a real asset. You'll find that you can focus your energies best in familiar surroundings with all your equipment close by. You'll associate your studio with creative activity, and it will be easier to get in the mood to paint there. It also helps to know where everything is so you can reach for a tool or brush without thinking about it.

Having the right light to paint by is also important. The ideal is overhead, color-balanced fluorescent lighting. You don't want to be painting in your own shadow. Ordinary fluorescent bulbs are too cool and incandescent lights, too warm, to make good color choices. It can be a real shock to see a painting done in cool fluorescent light under warm incandescent light.

A good, round watercolor brush allows you to paint broad strokes with the side of the brush, as well as some finer detail with the point.

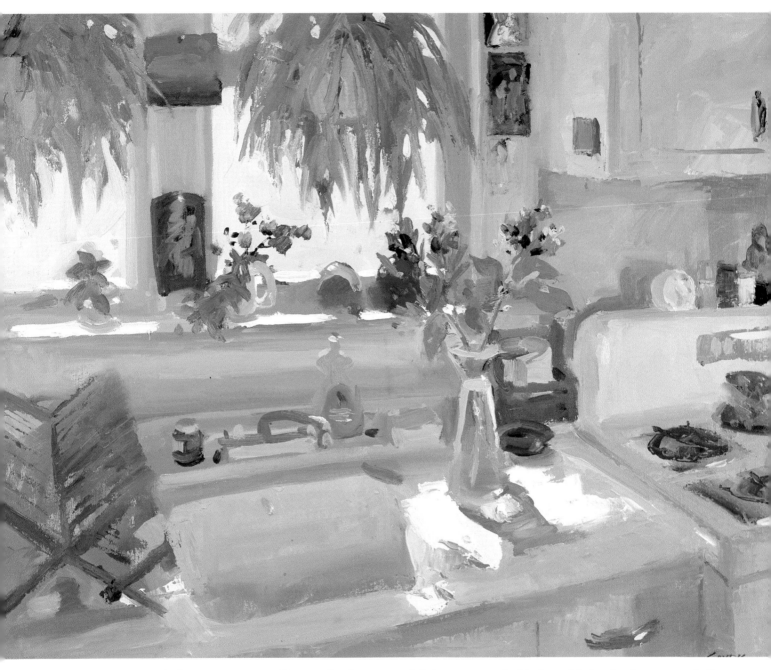

Kitchen Interior With Flowers
24″×30″
Charles Sovek
Oil on canvas
Collection of Lori Cutler-Goodrich,
Rowayton, Connecticut

Many artists have started their careers on the kitchen table, but having a space dedicated specifically to your art can be a real asset.

Materials for Oil Painting

The following list includes all the materials needed for basic painting in oil. As your knowledge increases, so will your stock of materials and your sensitivity to different colors and brushes.

First let's look at a list of suggested colors. You don't need to purchase them all right away; you can have a perfectly serviceable palette from just the starred colors. Purchase the rest gradually, as desired.

Oil Colors

- cobalt violet
- alizarin crimson *
- cadmium red light *
- cadmium yellow medium *
- cadmium yellow pale
- Naples yellow
- burnt sienna *
- permanent green light
- phthalo or viridian green *
- cerulean blue *
- ultramarine blue *
- black
- phthalo red rose
- brown madder
- cadmium orange
- cadmium yellow light *
- yellow ochre
- raw sienna
- burnt umber
- sap green *
- phthalo blue *
- cobalt blue
- Payne's gray
- white (large tube) *

Painting Knife

Be sure to get a painting knife with an inverted handle. It's much easier to manipulate than a flat palette knife.

Brushes

You need at least a dozen flat, bright or filbert bristles in sizes 1 through 12. (Two of each of the even sizes nos. 2, 4, 6, 8, 10 and 12 are good ones to start with.) A no. 5, 6 or 7 square sable softens edges and does detail work. Buy a small no. 2 or 3 square or round rigger for small accents and highlights unobtainable with any of the other brushes.

Brush Washer

A brush washer is a mandatory item for keeping your brushes clean between strokes. Silicoil makes a jar with a coiled wire at the bottom especially made for cleaning oil-painting brushes. You may choose to buy the jar and not the can of cleaning fluid that's sold with it. Turpentine or paint thinner will do the job just as well and at a fraction of the cost.

You could also make your own brush washer by using an empty peanut butter or jelly jar with a coiled-up wire coat hanger at the bottom. Whether you buy or make a brush washer, your oil-painting equipment isn't complete without one.

After a day's painting, clean your brushes one last time by first swishing them out in the cleaning jar and then thoroughly wiping them clean with your fingers using a mild soap and warm water. Make sure there isn't any excess paint left in the brush.

Brush Dauber

For a brush dauber, use a tuna or catfood can stuffed with a couple of paper towels to daub off a drippy brush before mixing a fresh batch of paint.

Painting Surfaces

Stretched or unstretched primed cotton or linen canvas, canvas board or 1/8"-Masonite (covered with two coats of gesso, one horizontal and one vertical) makes a suitable surface for oil paint. Sizes can range from panels as small as 9" × 12" all the way up to 20" × 24" or even larger. The best all-around sizes for the exercises in this book are from 11" × 14" to 16" × 20".

Palette

Plate glass with a piece of white paper or cardboard beneath is ideal to use for a palette in the studio but impractical for travel and location painting because of its weight and fragility. White Plexiglas, on the other hand, is suitable for both purposes. Ideally, you should have both glass and Plexiglas, with Plexiglas cut to fit your painting box for field work and the larger plate-glass palette on your taboret for studio work. White or gray paper tear-off palettes are fine in a pinch but tend to deteriorate after repeated brushing.

If you do choose a paper palette, use two of them: a larger one for holding the colors squeezed from the paint tubes and a second, smaller one placed on top of the first and reserved for the actual mixing of paint. When the smaller mixing palette is covered, simply tear off the filled page and you instantly have a fresh surface to work on without the inconvenience of disturbing the colors on the larger palette. Tan or brown natural wood palettes may be distracting to work on because the warm color and deep tone hamper judgment in mixing colors and values

Brush Can
12″ × 12″
Charles Sovek
Oil on canvas
Collection of
Martha Rodgers,
Atlanta, Georgia

objectively (especially when working on a white canvas).

Razor Blade Scraper

The hardware-store variety scraper made for scraping old paint from a building or window is particularly useful for quickly scraping wet or dry paint from your palette and providing a clean space for new mixtures.

Medium

Use undiluted turpentine for laying in a painting with thin washes or for ton-

ing a canvas. Some useful mediums are Res-N-Gel (Weber), Win-Gel (Winsor & Newton) and Zec (Grumbacher); while not as flexible as a mixture of stand oil (or linseed oil) and turpentine, they do give the paint a juicy quality that some painters find attractive. You'll also need some portable medium cups that can be stored in your painting box along with your paints and brushes.

Turpentine, Paint Thinner

Turpentine is used for washing out brushes. Wood-distilled gum turpen-

tine is less of a health hazard than petroleum-based paint thinner or mineral spirits.

Paper Towels or Rags

Rags are OK but tend to get saturated quickly, so you may want to use high-quality paper towels.

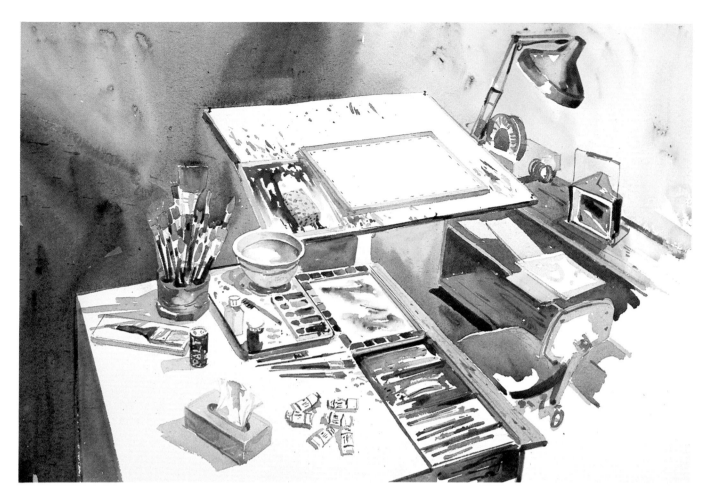

This is a watercolor of artist Al Stine's studio setup.

Materials for Watercolor Painting

Let's start with a look at the watercolor tools we just can't do without: brushes, colors, paper, a palette, boards on which to stretch the paper, water containers, sponges, tissue, a pocket knife, HB pencils, erasers, a spray bottle and a sketchbook. We'll also discuss some of the nonessential but handy items needed for special purposes.

Brushes

You'll find many excellent brushes on the market, and a few that are not so good. Buy smart when purchasing brushes. That almost always means buying the best brushes you can afford.

Red sable-hair brushes are the most expensive, but they are also undoubtedly the best. With proper care, they will last for a very, very long time and

will prove to be a wise investment. If you can't afford red sable, ox-hair brushes are a good second choice. There are also some new synthetic brushes out that are much less expensive but have gotten good reviews from watercolor painters. They should be springy and hold a good point. Synthetic fiber brushes with some natural fibers, such as the Winsor & Newton series 101 Sceptre, are very good choices, especially the rounds.

The following selection of brushes is recommended for the beginner. There are enough brushes to get the job done but not so many that choosing the right one becomes troublesome when painting.

Use a 2-inch Robert Simmons Skyflow for wetting the paper, for painting backgrounds and for painting skies. This brush does have synthetic

fibers, but still holds a good charge of water. For a versatile selection, use three red-sable flats — a 1½-inch, a 1-inch and a ¾-inch — and four red-sable rounds — nos. 12, 8, 6 and 4. The larger the number, the larger the brush. Use the largest brush you can when painting; small brushes invite fussiness. Keep an oil painter's ½-inch bristle brush for applying heavy pigment into wet areas and a small, ⅛-inch oil bristle brush for scrubbing and lifting out small areas of a painting like rocks and stones. Use a no. 4 rigger — a long, thin brush — to paint fine lines such as the rigging of ships, lacy tree branches and grasses.

Brushes are a major investment, so it pays to take good care of them. First, never use your sable or ox-hair brushes for acrylics, which tend to dry near the ferrule (the metal sleeve that holds the hairs on the wooden handle) and eventually ruin the springiness of the hairs. If you do use acrylics, use synthetic brushes.

Second, you should clean your watercolor brushes thoroughly after every painting session. Make it a habit to rinse them in clear water after each use. Many artists also use a mild soap to remove any residue that may linger in the bristles. Always make sure you rinse out all the soap.

Third, store the brushes in a way that protects the fibers, such as vertically in a brush holder, as shown in the illustration on page 5. Transport them taped to a piece of stiff cardboard. If you do store your brushes for a long time, put a few moth crystals in their container. Moths love sable hair. Of course, the best way to combat this problem is to use your watercolor brushes every day!

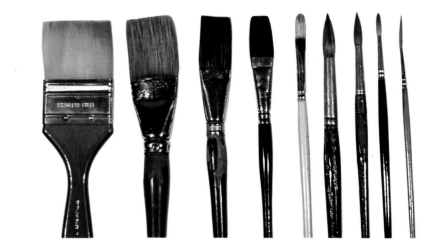

A selection of brushes appropriate for watercolors.

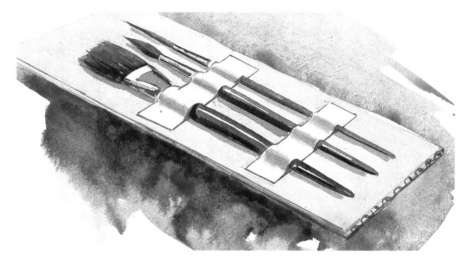

This is a good way to transport your brushes. For added protection, place a second piece of cardboard on top and tape the pieces together.

Paper and Board

Watercolor paper comes in various weights and textures. When we speak of the *weight* of the paper, we mean how much 500 sheets of a particular paper weighs. For example, if 500 sheets of a paper weigh 140 pounds, it's called 140-pound paper.

The less a paper weighs, the more it wrinkles and buckles when it is wet. Paper lighter than 140 pounds will need to be stretched. The heavier papers can be held down on the drawing board with large clips, and the very heaviest can be used unmounted.

The standard size watercolor sheet is 22″ × 30″. You can purchase full sheets from your local art supply store or by mail order. A half-sheet (22″ × 15″) is the size most commonly used by watercolorists. Paper can also be purchased in blocks. Watercolor blocks are pads of paper glued together on all four edges; you work on the top sheet, then slide a knife around the edges to separate it from the block when it is dry. Blocks come in sizes from 7″ × 10″ to 18″ × 24″, and in a variety of weights and textures.

Watercolor papers come in several different textures. Very smooth paper is called hot-press because it is made by passing the paper between large, hot rollers. Cold-press paper has a more textured surface because it has not been subjected to heat in its manufacture. Rough paper has a distinctly textured surface.

Paper texture and technique are closely related. Some techniques will work on rough or cold-press paper but not on hot-press, and vice versa. For instance, dry-brush techniques are not very effective on the smooth surface of hot-press paper because the dry brush is supposed to deposit color on the ridges of the paper's surface. On the other hand, the smooth surface of the hot-press allows for easier lifts and wipe outs.

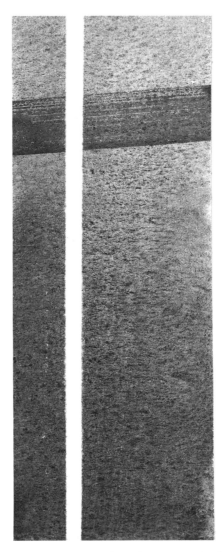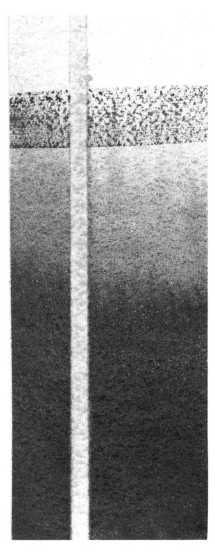

These are gradated washes of French ultramarine blue on 140-pound Arches cold-press paper (right) and 112-pound Crescent Rough Watercolor board (left). A strip of dry brush shows the difference in texture. Color was also lifted with a sponge after masking out an area with tape. As you can see, the color lifts off the board more easily than the paper, giving you much cleaner whites.

Palettes

You can use anything from a dinner plate to a butcher tray for your palette, but there are a number of excellent plastic palettes made just for watercolor. A John Pike palette, a plastic palette with a tight-fitting lid and twenty wells for colors, works well. The wells surround a large central mixing area and are separated from it by a small dam that keeps the mixtures from creeping into the colors. The top can also be used for mixing colors. This palette is airtight, so at the end of the painting session, you can place a small, damp sponge in the center of the tray and replace the lid. The colors will stay moist and ready for use for several days.

Notice that the list of colors includes a warm and a cool of each primary (for example, both Winsor blue—cool, tending toward green; and French ultramarine blue—warm, tending toward purple). This will allow you to create contrast in color temperature even when using one basic primary. Having a cool and a warm version of each primary helps you mix complements without getting mud.

Also keep an assortment of secondary colors (colors composed of two primary colors), including cadmium orange, an intense orange that's difficult to mix using other colors; and cobalt violet, another color that's hard to get by mixing.

It's a good idea to arrange your colors with the cool colors on one side and the warm on the other. Put your colors in the same place every time so that you won't have to hunt for them. You need to be thinking about what colors you want to mix, not where to find your colors.

Be generous when putting colors on your palette—you need plenty of pigment to paint a watercolor, and digging and scrubbing for color while painting will only disrupt your thinking process.

A basic palette of colors, as shown below, contains (left to right):
olive green
Payne's gray
cobalt blue
Winsor blue
Hooker's green dark
French ultramarine blue
cerulean blue
Winsor green
alizarin crimson
cadmium red
cadmium orange
cadmium yellow pale
lemon yellow
cobalt violet
burnt sienna
burnt umber
Van Dyke brown
raw umber
raw sienna
brown madder alizarin

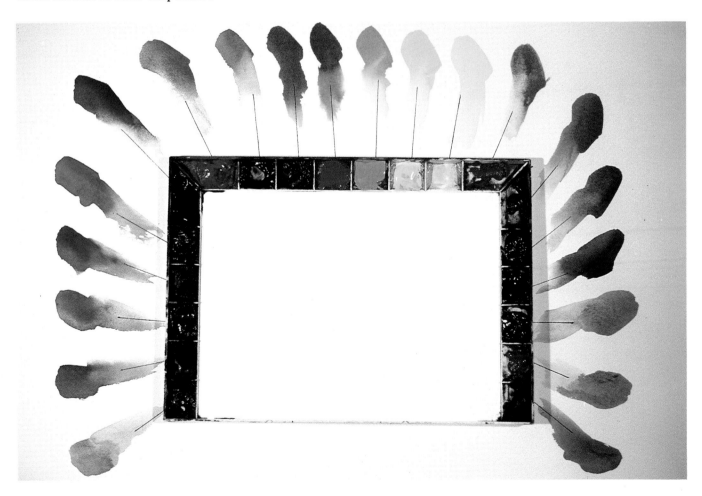

Materials for Pastel Painting

Many different kinds and qualities of pastel sticks are available today. Soft pastels give rich, paint-like textures. There are several good brands, and, generally, you get what you pay for. Rather than buying a set of pastels, you may choose to put together your own set, including soft pastels from many different brands. Start with dark, middle and light values of about a dozen colors.

Easel

It's better to work on an easel than a table. On an easel, the pastel dust falls away from the painting's surface. With a table, it just lies there getting in the way.

Drawing Board

Try a piece of ⅛″-Masonite.

Masking Tape or Clips

Use a clip or piece of tape across each corner to hold the paper on the board.

Bristle Brush

This is handy for brushing pastel away if it needs to be removed. It works equally well on paper or sanded board.

Fine Sandpaper

This may be used to remove pastel on paper and at the same time rough up the paper so it is receptive to pastel again.

Selection of Soft Pastels

Keep a dark, middle and light value of each of the colors you choose. If you

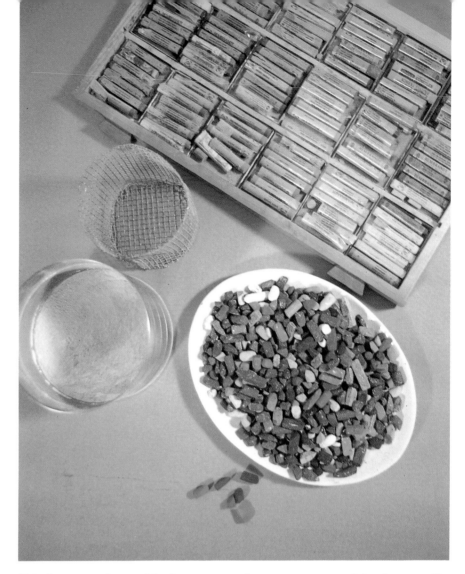

This shows pastels stored in drawers; pastels set out on a porcelain plate; a coffee can, wire basket and rice flour for transporting pastels; and a small group separated out to use.

start out with a small set, expand it so that you have a dark, middle and light value of each color in the set.

When you buy a new stick of color, cut a slit in the paper and break off a piece of pastel about ½″ long. Keep the pieces of pastel on a porcelain plate next to your easel. Store the sticks in a drawer until you need more of a particular color. Save the papers. They contain codes identifying the hue and value of each stick.

Store and transport your pastels in rice flour. Place the pieces of pastel in a basket made of heavy window screen. Then place this basket, in turn, inside a coffee can, and pour rice flour over the pieces. The rice flour cushions them, preventing breakage during travel. To use the pastels, just sift the rice flour out, dump the sticks back onto your palette, and you're ready to work.

Methods of Application

Pastel can be applied with a tip for linear strokes; with the side for broad, flat strokes; or as powder, sprinkled on or applied with the touch of a finger. You can't mix pastel colors the way you can mix a liquid medium. Pastels can be mixed only by painting one layer over another. You can blend pastels by working one stick of color into another, or by rubbing with a finger, stump or tissue. Also, you can move them around by painting into them with water or turpentine.

Removing Pastel

If the pastel gets too heavy, whisk some away with a bristle brush. Use this method on paper or board. Sometimes the pores of the paper become so filled with pastel that slick, shiny spots develop. What has happened is that the tooth of the paper has been crushed by repeated applications of pastel. The bristle brush won't help. You can revitalize these spots and remove the pastel by gently sanding the spots with a piece of light sandpaper. But don't use sandpaper on a sanded board; the sandpaper will remove its sandy surface.

Fixative

Fixative causes the light values to darken and the colors underneath to bleed through to the surface. Therefore, it is not wise to seal a finished painting with a fixative. If you are going to use fixative, use it only to seal coats of pastel you intend to cover with an additional coat. Instead of spraying a finished painting with a fixative, strike

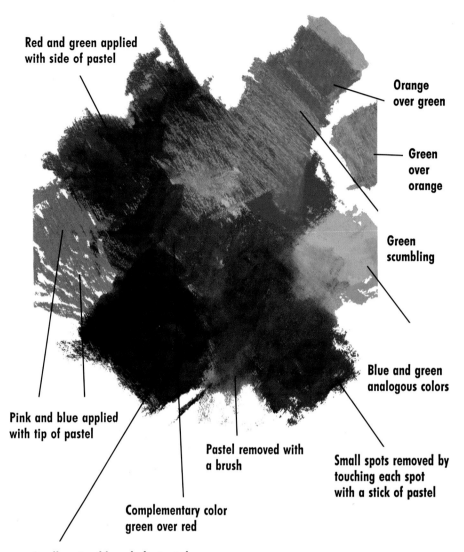

Red and green applied with side of pastel

Orange over green

Green over orange

Green scumbling

Pink and blue applied with tip of pastel

Blue and green analogous colors

Pastel removed with a brush

Small spots removed by touching each spot with a stick of pastel

Complementary color green over red

Small spots of board eliminated by touching with the little finger

the board several times on the back. These blows knock off any pastel that is loose enough to fall off later. If small, open areas result, retouch them before framing.

Paper and Board

Many of the pastel paintings in this book were done on Canson paper, etching paper or Masonite board. Of the Canson papers, the lighter brown or gray tones work well with pastels. Avoid the dark papers and brightly colored ones. The front side of the Canson has a screenlike texture that some artists find objectionable, but the back side is smoother. While any etching paper will work, try the texture of German etching. Tone the etching papers with loose washes of acrylic or casein.

Materials for Colored-Pencil Drawing

Like other mediums, colored pencils should be selected to suit your specific needs. Recognizing whether your work is soft, loose, precise, evocative or moody is an important consideration in the choice and application of colored pencils and their related accessories. Once you have taken stock of your needs and interests, purchase the best pencils you can afford. The color should flow smoothly and look rich. Try to stay away from colored pencils that are manufactured with school-age children in mind; they produce bland colors. Test a few pencils before buying a full set. It also is wise to make sure that individual pencils of the brand you choose to purchase are available on an ongoing basis.

Colored Sticks

Some pencil manufacturers, such as Berol Prismacolor and Rexel-Cumberland, produce drawing sticks that are color-keyed to their existing line of colored pencils. These sticks resemble Conte or pastel sticks in shape and length and have the approximate consistency of the colored pencil to which they are keyed. Since they are not encased in a wooden sheath, they can produce a wide flow of color along their whole length (approximately 3″).

Erasers

Erasers have other uses besides removing color. They can tone color applications, soften harsh treatments, and highlight specific areas of a darker application. The only eraser you should avoid is the pink school eraser. Over time it hardens, and if it feels dry to the touch, it will probably stain your drawing surface with its telltale pink. You should also avoid any erasers in which trendy colors were imbedded during the manufacturing process.

Plastic erasers are user-friendly because they can be accurate in areas

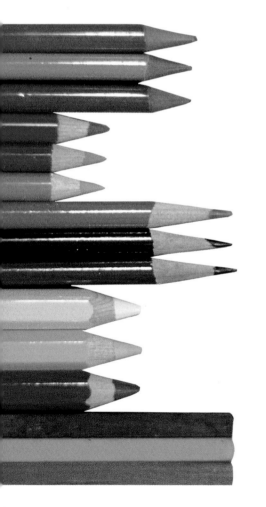

Colored pencil leads come in various thicknesses. Lyra of Germany produces the thickest colored-pencil leads, which are wonderful for free-flow sketching and finished drawings. Berol's Verithin offers a hard, thin lead for precise lines.

where fine definition is necessary, and can soften tonal values without harming the drawing surface.

Gum erasers are soft and useful in blending and erasing, but their propensity for crumbling easily makes them less desirable.

Kneaded erasers are completely flexible and can be molded to suit the artist's purpose. They can be shaped into a point or given a wide, flat or round configuration. These erasers seem to eat residue and come out clean when kneaded.

Cut and shaped to suit individual needs, erasers are an important part of the drawing process. Try to keep your erasers as clean as possible by rubbing away residue on a scrap piece of paper. (Erasers sometimes will retain color picked up from previous uses.)

Sharpeners

Small, hand-held sharpeners are inexpensive yet precise. The most resilient are made of metal. Some come with two sharpening slots: one for wider pencils and one for thin-body pencils. Beware of electric sharpeners—the wax in colored pencils tends to clog them.

Sandpaper blocks are used to give a pencil point a custom shape. Many artists create their own strokes in pencil drawing and use sandpaper to get the precise pencil point. Sandpaper blocks are available in various shapes and sizes, and they often come in thin pads.

Tortillons

Tortillons (pronounced *tor-tee-yons*) are tightly rolled paper stumps used to soften or blend colors. They come in various sizes and thicknesses. One or both ends are sharpened to a point. Once used, they retain particles of pigment, which can be removed by sanding with the sandpaper block. This cleaning process also will help maintain the tortillon's point.

Colored sticks cover large areas of a drawing surface where tonal layering using a regular pencil would be extremely time-consuming. They are also a less constrictive tool for drawing.

Erasers are useful for blending or eliminating color, but remember the fragile nature of drawing papers. A combination of utility blade and eraser may be needed to eliminate unwanted color completely. Be patient and careful; the drawing surface must not be damaged.

Materials for Pen and Ink

One of the advantages of pen and ink as an artistic medium is the convenience of the materials, which are few in number and small enough to tuck into a pocket. One needs ink, a tool with which to apply the ink, and a surface to work on.

The Pen

Fountain pens, felt-tip markers, fiber-tip pens, art pens, ballpoint pens, reeds, sticks and feather quills can all be used with success. Each of the aforementioned writing tools, however, has limitations. The characteristics to look for in an ideal pen are a steady, reliable, leak-free flow, and a nib that is precise and can be stroked in all directions.

Originally, bird feathers (quills) were used as writing tools. Generally, duck quills were used, but when a finer line was desired, crow quills were selected. The ends of the quills were sharpened to a point with a *pen knife*. The quill tip was dipped into the ink, and the hollow feather shaft held enough ink for several strokes.

The *crow quill dip pen* is an adaptation of the early feather quill dip pens. It consists of a plastic or wooden holder and a removable steel nib. With Hunt nibs no. 102 (medium) and no. 104 (fine), the crow quill will provide a good ink line. The tool cleans up easily and is inexpensive. It's useful for applying colored inks when you want many color changes. However, crow quills are limited in stroke direction and have a tendency to drip and splatter; the redipping process interrupts the stroking rhythm.

The *technical pen* is an advanced drawing instrument consisting of a hollow nib, a self-contained nib, a self-contained ink supply (either a prefilled cartridge or a refillable cartridge) and a plastic holder. Within the hollow nib is a delicate wire and weight, which shifts back and forth during use, bringing the ink supply forward. This wire *should not be removed* from the nib.

The nibs are made of steel and are quite durable on paper surfaces. More expensive jewel-point nibs (the writing surface is sapphire) and tungsten points are available for use on more abrasive surfaces. Because the hollow technical pen nibs are circular in design, they can be stroked in any direction. The resulting line is precise, allowing you to achieve engraver's perfection, a loose sketchy style, or a finely detailed pointillistic technique. When properly maintained, the technical pen is reliable and provides a consistent, lead-free ink flow. Some consider it the best inking instrument available.

There are many styles and brands of technical pens available. One favorite is the Koh-i-noor Rapidograph. It is dependable, and the refillable cartridge allows you to choose your own ink. The pen-and-ink illustrations in this book were drawn with a Rapidograph pen.

Note: The following information on use, care and maintenance of a technical pen refers directly to the Koh-i-noor Rapidograph, but it will be useful for other brands of technical pens, many of which are similar in design, as well.

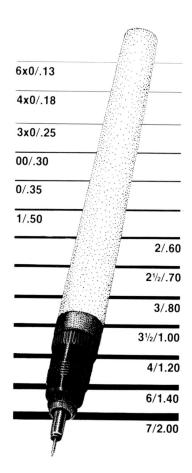

6x0/.13
4x0/.18
3x0/.25
00/.30
0/.35
1/.50
2/.60
2½/.70
3/.80
3½/1.00
4/1.20
6/1.40
7/2.00

Nib Sizes

Technical pens come in various nib sizes, ranging from very fine to extra broad. The line-width chart above shows both the Rapidograph nib sizes and the equivalent metric line widths.

Nib sizes from $6 \times 0/.13$ to $3 \times 0/.25$ provide a delicate to fine line, good for detail work. Nib sizes 00/.30 and 0/.35 provide a medium line that's nice for making quick sketches, creating texture and detailing larger drawings. Nib size 1/.50 provides a heavy line that is good for bolder techniques and fill-in work. Nib sizes 2/.60 and larger can be

useful for very large, bold illustrations and for filling in large areas. For a first pen, I recommend nib size 3 × 0/.25. It's fine enough for detail work, yet it can produce nice texture and value changes.

Ink

India inks are composed of water, carbon black particles for a rich, dark color, and shellac or latex for a binder. Different blends of these ingredients determine the ink's opacity, open pen time, surface drying time, adhesion and permanence.

Very black, opaque inks have a higher ratio of pigment in the mixture. Such inks give the greatest amount of contrast and create lines that reproduce well. Keep in mind that heavily pigmented inks may not flow as well in the finer-nibbed pen sizes.

Open pen time is an important factor when selecting the proper ink. It refers to the amount of time the ink will remain fluid in an open, inactive nib. (Pens should be capped when not in use.) If you use a 4 × 0 or 6 × 0 pen nib or work in a very dry climate, choose a free-flowing ink with a longer open pen time. They are less apt to clog.

India inks labeled "permanent" should hold up under high-humidity situations, adhering well to the drawing surface when touched. However, even "waterproof" inks may smear or lose pigment when overlaid with brush-applied washes of watercolor, acrylic, diluted ink or oil paint. Test the ink before applying any type of wash to your sketch.

Dye-based colored inks have a tendency to fade over a period of time. For a brown (sepia) tone or colored ink, I recommend Rotring's ArtistColor. It is a finely pigmented, transparent, permanent acrylic that can be used in technical pens.

Liquid Paper for pen and ink is useful for correcting small mistakes, or making corrections on art pieces that are to be used for reproduction only. To avoid clogging nibs, let the correction fluid dry several minutes before inking over it.

I have not found an effective way of masking or removing large mistakes from pen-and-ink drawings meant for direct viewing. In most cases, a large mistake means starting over. However, with luck, you might be able to disguise a mistake underneath additional ink lines.

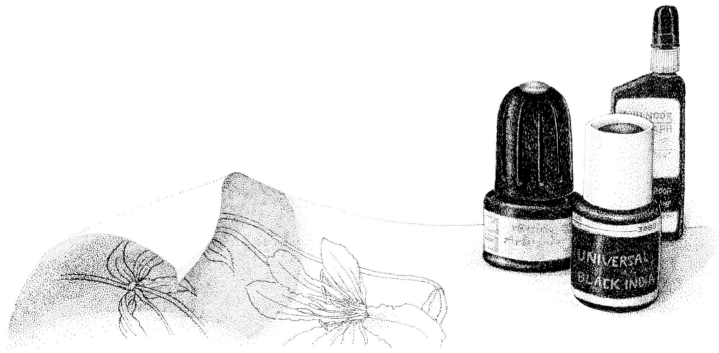

Chapter Two
DRAWING AND COMPOSITION
Constructing the Head and Features

The head is shaped very much like an egg, and by applying certain simple measurements to this ovoid shape, it's possible to properly locate the position of all the human features. Of course, you will find people with long noses or small ears. However, these adjustments can easily be made once you have located the features' approximate positions on your drawing. This system works! You will find that every head in this book is developed from a basic egg-like shape.

As you study this section, it's a good practice to make sketches as shown in the illustrations. Draw the ovals and grids, and measure where the features are located. This will help you remember these important relationships.

The Structure of the Head

Now let's study the egg-like shape of the head. Viewed from the side, the major axis of the head is tilted, as shown at right (top). The form widens at the top and presents a more or less vertical face. Notice how the skull fits into this simple shape, which helps us see the underlying structure beneath the visible features. The skull at left (bottom) has a vertical line drawn down its center. This line helps balance the features when you're drawing a head-on view.

The eyes are located halfway between the top of the head and the bottom of the chin. Viewing them from the

side, you can see that they are located *back* from the surface of the ovoid in the bony eye socket.

The eyebrows are placed slightly above the eyes on (or near) the brow bone. The bottom of the nose is located halfway from the brow line to the bottom of the chin. These same measurements are used to place the nose on the side view. The nose projects in front of the facial oval.

The ears are located *behind* the ver-

tical line drawn halfway between the face and the back of the head; they extend from the brow line to the bottom of the nose. Notice that the neck is attached to the head at an *angle*.

All that's left is to place the mouth, which is located about one-third the distance from the bottom of the nose to the bottom of the chin.

Remember these simple relationships and you have the fundamental information you need to draw portraits.

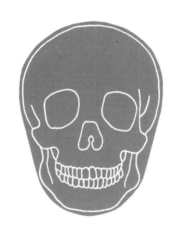

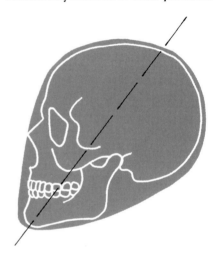

From a straight-on view, the skull fits into an egg-like shape.

Viewed from the side, the ovoid shape of the head widens at the top and the major axis is tilted.

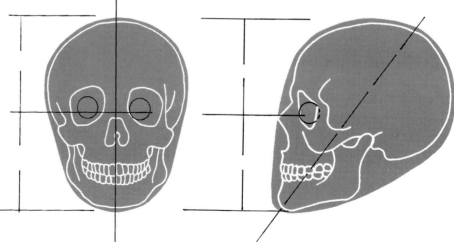

The eyes are located halfway between the top of the head and the bottom of the chin.

The eyes are nested in the eye sockets, back from the surface of the face.

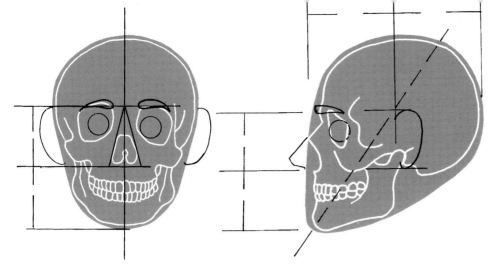

The bottom of the nose is halfway between the eyebrows and the chin. The ears fit between the lines locating the eyebrows and the bottom of the nose.

The ears are located behind a vertical line drawn halfway between the front and back of the skull.

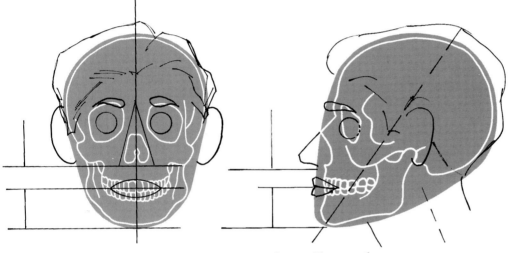

The mouth is one-third the distance from the bottom of the nose to the chin.

In this profile view, the same measurements are used to locate the features as in the front view.

This facial diagram shows the location of the features.

This side view of the facial diagram shows the location of the features in profile.

Blocking in the Head

Here are a few of the drawings that went into making these watercolors of Tracy. These sketches help you see how the relative measurements described on the previous pages were used to draw this head. The basic ovals were done on tracing paper, as were the rest of the drawings. A series of tracing-paper overlays was superimposed, one by one, to develop the drawings until final drawings were achieved.

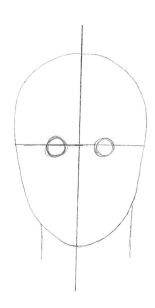

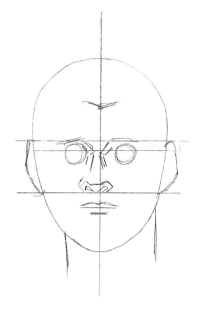

Here is the basic oval shape of the head. The vertical line helps in balancing the features. The eyes are spotted about one-eye-width apart and approximately halfway between the top of the head and the chin.

Next the brows are placed a bit above the eyes, and the bottom of the nose is located halfway between them and the bottom of the chin. The mouth can now be put in its place, one-third of the way down from the bottom of the nose to the chin.

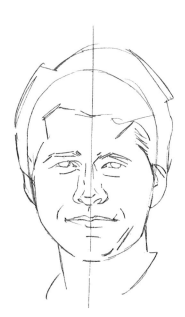

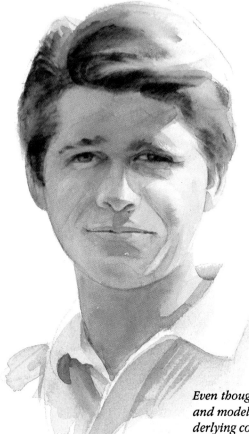

After the basic head is drawn and the features are located in their proper positions, it's time to begin to modify the face to become that of your model.

Even though realistic features, colors and modeling have been added, the underlying construction of the head is still visible.

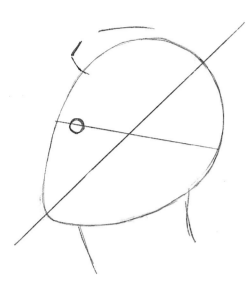

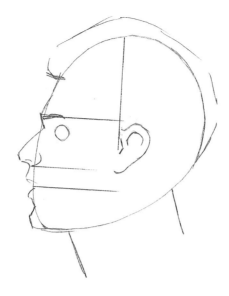

Viewed from the side, the ovoid form is larger at the top, and the axis of the head is tilted, presenting a more or less vertical front. The eyes are drawn back from the front of the face.

The features are located the same as they were in the front view; however, notice that the ear is placed on a line drawn halfway between the front and back of the skull.

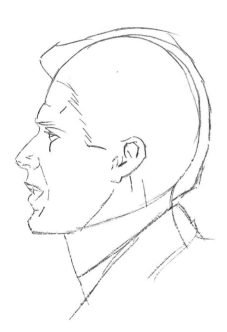

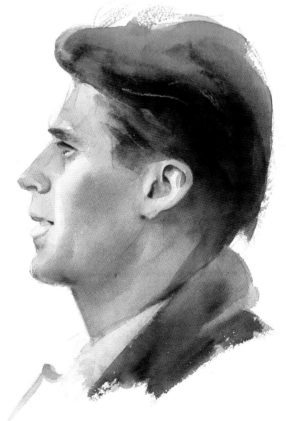

In this sketch, the features begin to develop. The jawline is defined, and the hairline is located at the temples.

In this profile view, you can see once more the basic construction that went into drawing this head. No amount of fancy brushwork can compensate for a head that is poorly drawn. However, by learning these simple relative measurements, even beginners will soon find themselves drawing convincing heads.

Capturing the Features

While every face has two eyes, two ears, a nose, a chin and a mouth, no two faces are exactly alike. Therefore, every face requires careful observation.

In this section, we will look at the construction of the features and make a simple analysis of them. Many times it's far better to suggest a feature than to draw or paint every detail. Once you understand the construction, you can convincingly omit detail and the effect will carry. But first, you must understand everything that you omit.

Eyes

It has been said, "The eyes are the windows to the soul." They are certainly the most expressive feature of the face. A single glance can reveal excitement, joy or longing. The eye is well protected by the bony structure that surrounds it. Not only is it set deep in the eye socket, it is further protected by the frontal bone of the forehead above, the inner side of the nose, and the cheek bone below. These are important things to remember when you place the eye.

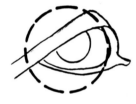

The artist must always think of the eyeball as a sphere.

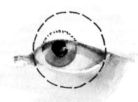

The upper lid slides up and down over the eyeball. The lower lid, however, moves very little.

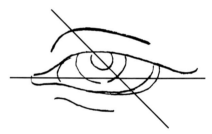

The arrow shows how the forms go in and out. The upper lid is somewhat thicker than the lower lid.

In a three-quarter view, the eye is nearly almond shaped. The lid curves around the eyeball.

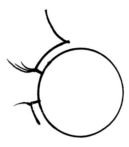

Even though you show very little of the eyeball, the part you do see must give the impression of roundness.

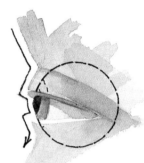

The high point of the upper lid is toward the nose: the low point of the lower lid is away. The lids join at almost a right angle at the outer corner.

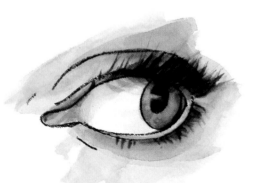

The lids are separated by a pink membrane at the inner corner of the eye. The eye is moist and reflects any light that strikes it. The location of the highlight is determined by the direction from which the light is coming.

The upper lashes and lids are much thicker and longer than the lower ones. Depending upon the individual, the eyes are located about one eye-width apart.

Nose

We don't usually think of the nose as expressing emotion, but who among us has not "turned our nose up" at something distasteful. A nose can give character to a face. We think of a large nose as being Roman or aquiline. The witch in a fairy tale may have a hooked nose. A flat or broken nose might be associated with a boxer.

The nose has a long, wedge-shaped form. It's attached to the forehead with another, smaller, wedge shape. Where these wedges meet, the nose is usually thin and becomes wider at the bottom. The upper section is made of bone; the bottom is made of cartilage. This cartilage is flexible and responds to the pull of the facial muscles, which can cause the nostrils to twist or dilate in anger as well as in a smile.

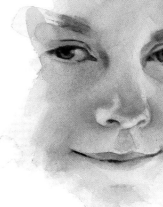

Children's noses are shorter and softer in appearance than adults'.

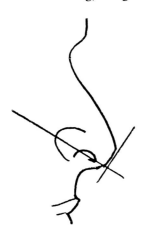

The tip of the nose usually slants upward, while the nostrils slant down.

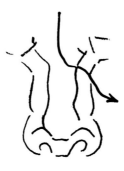

There is a step down from the brow to the narrowest part of the nose, right between the eyes.

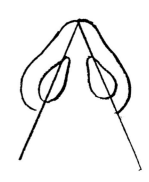

Viewed from beneath, the nostrils slant toward one another at the tip.

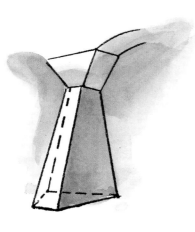

Think of the nose as a long, wedge-shaped form attached to the forehead with a small, wedge-shaped form.

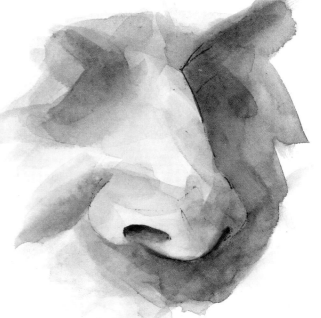

The bottom of the nose is composed of five pieces of cartilage. Two form the nostrils, a third separates them, and another two form the tip. This part of the nose continues to grow and change shape with age. The upper part is bone and is responsible for the nose's basic shape.

Mouth

Of all the features, the mouth is the most flexible. With every word and emotion, the mouth can change its size and shape.

The upper and lower lips vary greatly in appearance. The upper lip is longer and thinner, while the lower lip is fuller. The upper lip can be thought of as having three sections, while the bottom has only two. Viewed from the side, the upper lip projects over the lower one, and there is a slight depression where the lips and cheeks meet.

The general shape of the mouth is greatly influenced by the dental arch beneath the lips. In your drawing, remember that the mouth should always reflect this curve of the teeth. If you see a person who has lost his teeth, you are bound to notice that the mouth is sunken and loose, and less of the lips are visible.

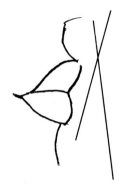

In a profile view, the upper lip usually projects above the lower one.

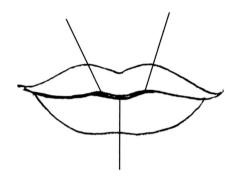

The upper lip is divided into three sections, and the bottom, into two. The center portion of the lips is directly under the nose.

A smile or laugh shows the upper teeth, while the corners of the mouth form a small depression or hollow where they meet the cheeks.

The upper lip is flatter and more angular than the bottom lip, which is fuller and rounder.

There is a slight furrow under the bottom lip, more noticeable in men than in women.

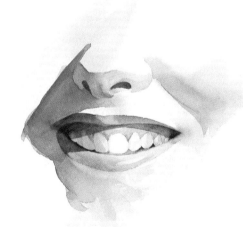

The shape of the mouth and lips should reflect the curve of the dental arch.

Ears

Ears vary greatly in size among individuals; furthermore, some project from the side of the head, while others lie almost flat. The ear has a fleshy lobe at the bottom, but the rest is mostly made of cartilage. The curves and whorls of the center bowl section are where most differences occur.

As we have seen, the top of the ear is on a line with the eyebrow, and the bottom is on a line with the base of the nose. Viewed from the front, the ears slant in at the bottom, parallel to the sides of the head. It is when the head is turned at an angle that drawing problems may arise. Remember that the ear is located behind an imaginary line halfway between the front and back of the head.

The ear is somewhat saucer shaped. The center section resembles a bowl.

When viewed from the back, the outside of the bowl is visible.

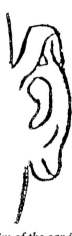

The outside rim of the ear is curved to act as a scoop for sound waves.

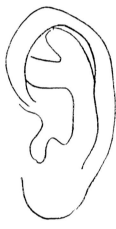

The flap that protects the ear canal's opening contrasts with the shadowed recesses.

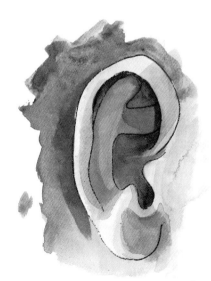

Notice the differences in the whorls of cartilage that make up the outer ear.

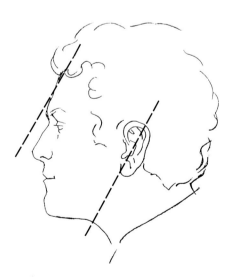

The ear is located behind *an imaginary line located halfway between the front and the back of the skull.*

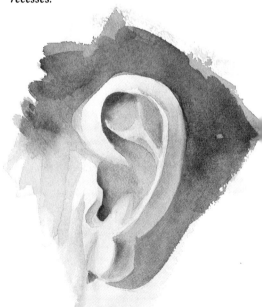

Your model's ears are unique and must be drawn with the same care as the rest of the features.

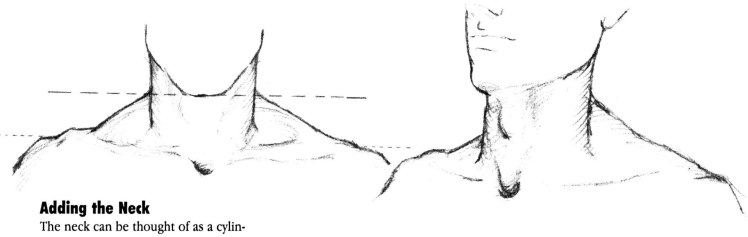

Adding the Neck

The neck can be thought of as a cylinder, a very strong column rising from the sloping platform of the shoulders, as you see in the illustrations above.

Study the drawings at right. There are seven vertebrae in the neck, each capable of movement, like links in a chain. They allow the head to turn and twist in every direction except 180 degrees to the back. Notice that the neck isn't perfectly straight. It projects forward even when we are sitting up very straight.

The strength of the neck is at the back, where the trapezius muscles rise from well below the shoulder blades, and extend out to the shoulders and up to the base of the skull, as shown in the illustration below. These trapezius muscles hold the head erect.

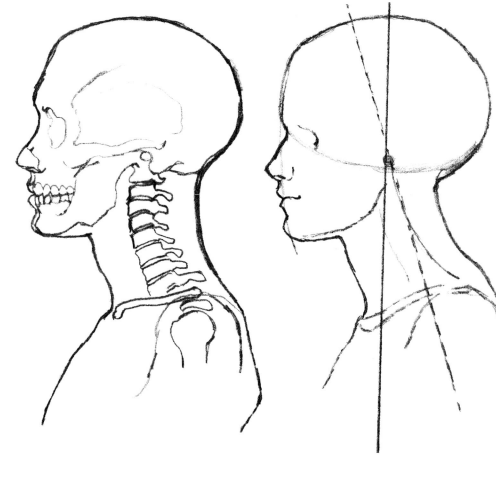

The neck, at the back, begins at a point on a level with the ear opening and the base of the nose. From the front, the visible neck begins at the chin and extends this same distance downward to the collarbone protrusions. Study the drawings at right.

Descending from behind the ears to a pit at the base of the front of the neck are two slender muscles called "bonnet strings" or sternomastoid muscles. These pull the head forward and back and allow the head to turn from side to side. Between these muscles, at the front, you will see a man's larynx or Adam's apple.

Notice that the neck can be stationary and still allow the head to nod forward and be thrown back, as shown in the drawings below right.

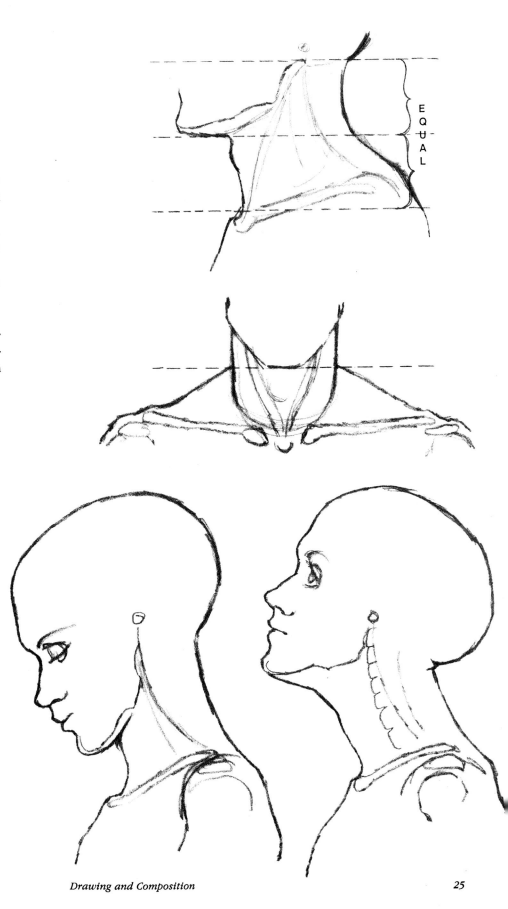

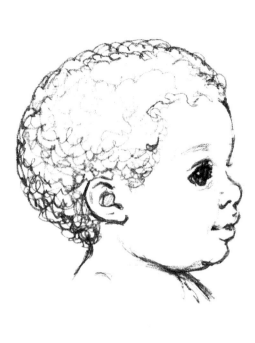

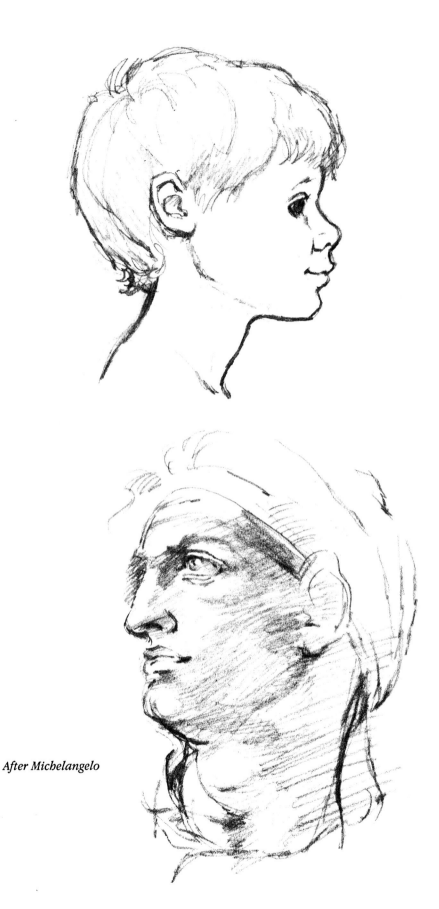

Children's and Youths' Necks

Until a child is three or four months old, the neck is too weak to support the head, which is proportionately very large for the body. The neck in a new-born baby and up to age two is hardly visible as such, but may be indicated by creases in rolls of fatty tissue. As the child grows, the neck becomes more perceptible and takes on a rather slender and delicate appearance.

When a boy of sixteen or seventeen becomes active in athletics, the neck thickens. As a portrait painter, you should watch for this, as the heavy, sturdier neck is a good way to indicate a young man growing out of boyhood. All professional athletes show great strength in the neck.

Michelangelo gave all his people sturdy necks, both men and women. There is something heroic about a very strong neck in a painted image.

After Michelangelo

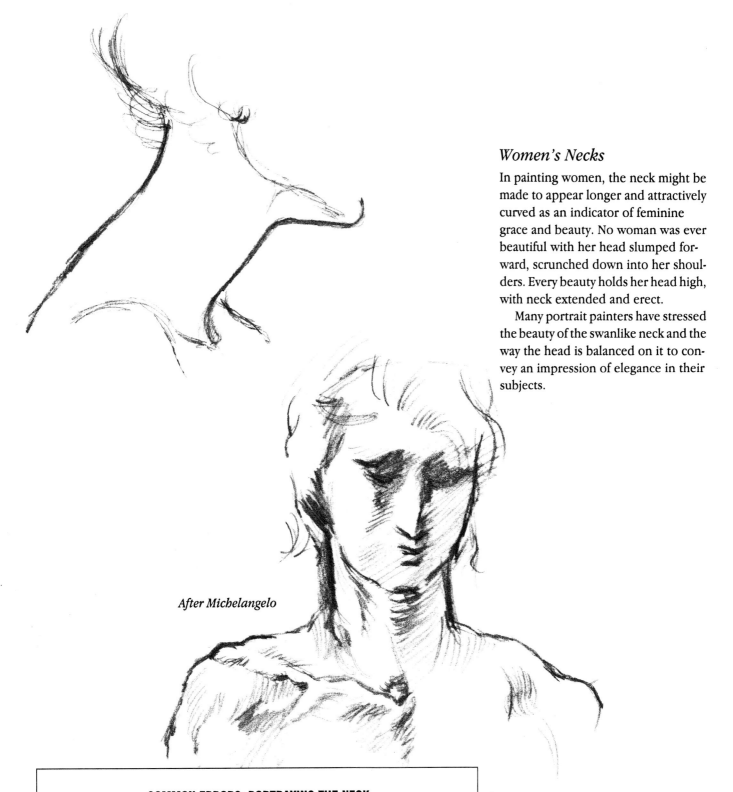

Women's Necks

In painting women, the neck might be made to appear longer and attractively curved as an indicator of feminine grace and beauty. No woman was ever beautiful with her head slumped forward, scrunched down into her shoulders. Every beauty holds her head high, with neck extended and erect.

Many portrait painters have stressed the beauty of the swanlike neck and the way the head is balanced on it to convey an impression of elegance in their subjects.

After Michelangelo

COMMON ERRORS: PORTRAYING THE NECK

The neck too long or too short. Poorly observed. Try to relate the neck to the chin, the collar.

Too thick or too thin. If the neck is too heavy, the figure may look stodgy. If the neck is drawn too thin, the figure may appear weak.

Drawn as a tube with a ball on top of it. The neck looks stiff and unnatural.

No involvement between the neck and the shoulders. Without the smooth flow from the neck to the torso, the body lacks grace and movement.

Transferring Your Drawing

It's a good idea to make preliminary sketches on tracing paper. When you are completely satisfied with the drawing, transfer it to paper, board or canvas. Obviously, there remains the problem of *how* to transfer the drawing.

Commercial graphite papers are available, but the lines they produce sometimes seem to repel pigment. Furthermore, these lines are very difficult to erase. With handmade graphite paper, you are simply using your own pencil pressed onto the paper or canvas in an indirect way.

Making graphite paper is a rather messy job, but it's easy to clean up afterwards. Use a graphite stick or a soft drawing pencil (4B or softer) and good-quality tracing paper. Quality tracing paper is important because it must withstand a great deal of abuse. It should not tear easily, and it should be able to bear repeated use.

Cut the tracing paper to about 18″ square (although any convenient size will do). Then, using a graphite stick or the side of a soft-lead drawing pencil, scribble lines close together, back and forth across the tracing paper, first in one direction and then in another. After the paper is pretty well covered, use a facial tissue moistened with rubber-cement thinner to rub the lines together until the paper has a more or

With a soft-lead pencil or graphite stick, scribble lines back and forth in both directions.

Use a facial tissue to rub the lines together until the paper has a uniformly gray surface.

less uniform gray surface. The thinner will cause some streaking, but it helps keep the graphite from dusting off of the paper. Run a piece of Scotch tape around the outer edge of the finished graphite paper to further protect it from tearing.

Before you attempt to use your new graphite paper, be sure to remove the excess pencil dust. This is important because if you have not been careful to blow, shake or brush off the excess graphite, it may leave black dust on your watercolor paper. Your desk and hands can get pretty grubby during this process, but soap and water will clean things up in no time.

To use the graphite paper, just tape the final drawing into position on the paper or canvas, slide in the graphite paper, graphite side down, and trace the drawing. A red ballpoint pen makes it easy to see where you have been.

Another way to transfer your drawing is to hold it to the light—a windowpane will do—and use a soft-lead pencil to retrace your drawing on the back side. This eliminates a great deal of mess, but in my experience, does not make as clear a copy; further, if you intend to transfer many drawings, this method may prove to be more work in the long run.

Tape the final drawing into position on the paper or canvas, slide in the graphite paper and trace the drawing.

PATTERNS OF LIGHT AND DARK

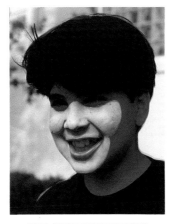

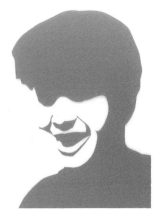

THE SHADOW PATTERN

When you do your drawing, look for the large pattern of lights and darks. Here, an orange overlay shows this pattern over the photo.

THE SHADOW SHAPE

Here is the basic shape of the shadow by itself. If there is not strong lighting on your subject, you must carefully observe the subtle shadows you see to create a pattern.

Composing the Portrait

Up to this point, we have been concerned with the mechanics of drawing a face. However, no matter how good the face looks, the painting won't be attractive unless the portrait is composed well on the paper or canvas—perhaps in some kind of setting. You may want to show a child at play with some favorite toys, or show a businessman at his desk. Composing a portrait presents the same design problems as does any other subject, and it follows the same rules.

A Pathway for the Eye

Successful composition is the result of creating a path for the viewer's eye to follow in the picture. Unity, dominance and contrast can be used to make a trail that the eye can follow inside the boundaries of the picture. Unity is the key. Unity is achieved when all the elements of an arrangement are subordinated to one plan. There should be one obvious route for the eye to follow, and one major idea for the viewer's mind to grasp.

To create a unified composition, some element has to dominate. There should be one center of interest, which should act as a magnet for the eye. If there are competing centers of interest, the viewer will be confused or disappointed. Contrast, such as a dramatic difference between light and dark or warm and cool colors, attracts the eye to a definite focal point. Contrast also entertains the eye once the viewer's attention has been attained. Study the following examples and trace for yourself the probable paths for the eye in each composition.

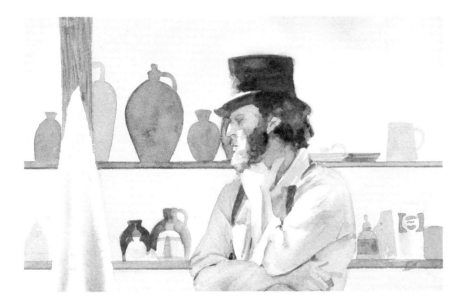

Bad: *The shelf intersects the model in such a way as to make his head appear to be a part of the pottery. The towel and soft drink cup are totally unrelated to the composition; they destroy the unity of the picture by creating competing centers of interest.*

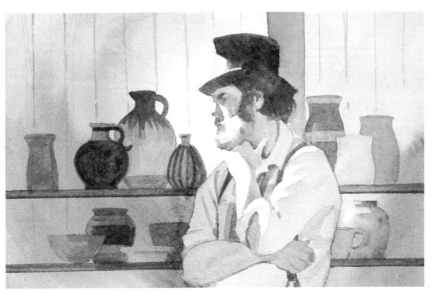

Better: *By lowering the shelf, organizing the pottery, and eliminating the unrelated objects, the model now becomes the center of interest. The shelves and upright also help direct the eye to the model, making him the focal point.*

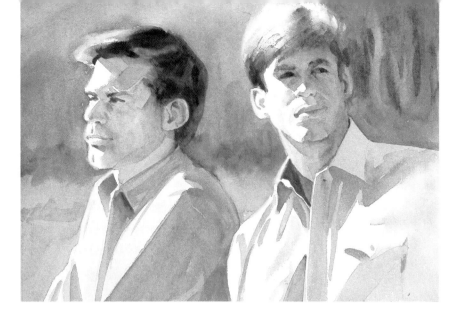

Bad: *The figures in the sketch fight for attention. Because both appear to be looking out of the picture, the viewer's attention is drawn to the void between the heads or out of the picture altogether.*

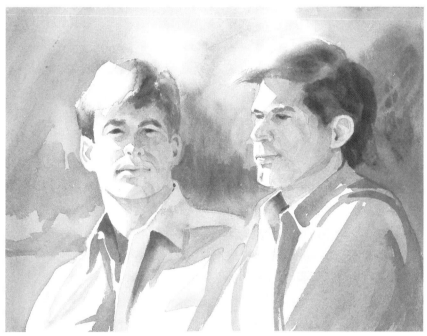

Better: *The composition has been improved now that the figures face into the picture area, keeping the eye from wandering toward the edge. However, neither face is dominant.*

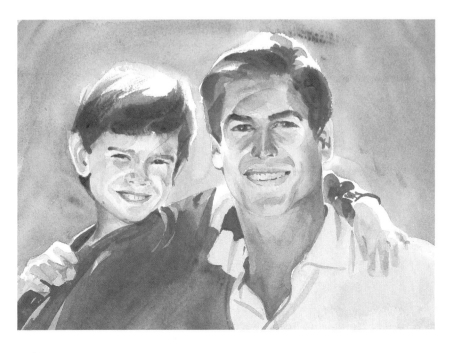

Best: *Compositions with two or more persons are generally more successful when the models interact with one another or are performing a joint action. Here, both subjects return the viewer's gaze, capturing attention and maintaining unity.*

CHOOSING A POSE
Work From a Live Model or Photographs

It takes two to paint a portrait, and your portrait will suffer if you don't really feel something for your model. Ask yourself, "What is it I want to say about this person?" You might write the answer to that question on the corner of your drawing board when you begin a portrait. The note will serve to keep you focused on your initial emotional response.

Norman Rockwell said it a long time ago: "People get out of your work just about what you put into it, and if you are interested in the characters that you draw, and you understand them and love them, why, the person who sees your pictures is bound to feel the same way."

Model or Photo?

You can see more and better when you paint from a live model than when you paint from a photograph. It's as simple as that. There are many other advantages to having a live model, not the least of which is the important opportunity to get to know the person and sense the personality behind the face.

But let's admit it, outside of a classroom situation, it's not always practical or feasible to have a person sit for the length of time required to complete a work. Sometimes the best pose is captured by the camera. With children, an interview and a lot of photos is often the best way to go. Just because the artist worked from snapshots doesn't

make a portrait bad. Once the portrait is completed, it must stand on its own merit. Almost all professional painters, even the best of them, use photographs to some extent.

If you are new to portraiture, paint someone you know. Paint from several photographs, working alone in your own surroundings. That way, you'll feel comfortable and can concentrate on painting. After you are more sure of yourself, there will be time to work from a model. Only you know how you feel. If you have the opportunity to paint from a model, go for it. Every artist starts at the beginning, and you should never be ashamed of any sincere effort.

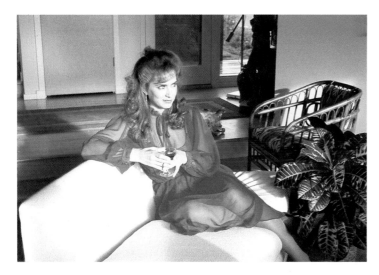

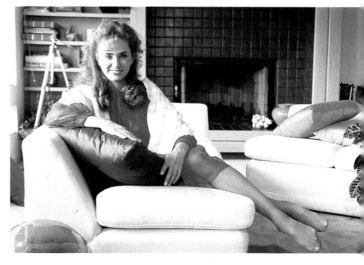

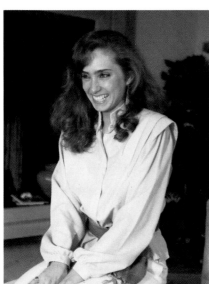

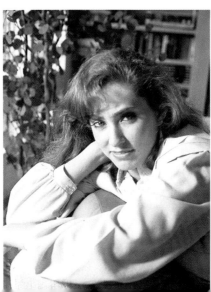

Artist Jan Kunz hired model Patricia Patrick. Pat brings everything from party dresses to slacks. First she wears a red dress, but the brilliant color challenges her face for attention.

They attempt to soften the look with the addition of a scarf. The scarf frames her, but it seems a less formal pose would better express Pat's outgoing personality.

After changing to a simple cotton blouse, Pat at once seemed more relaxed. Her habit of putting her hand in back of her head is noted.

Posing a Model

If you're working with a live model, setting up the pose is the first step. Let's start with a few basic tips. Place your model in a setting that's in keeping with the mood, age or occupation of the sitter. For instance, an elderly woman would look natural in a comfortable chair, or a rancher might have a saddle or some other related paraphernalia nearby.

Be sure your model is in a comfortable position. If she has a habit of tilting her head in a certain way, paint her that way. Your models will squirm less if they are posed in a position that is natural to them.

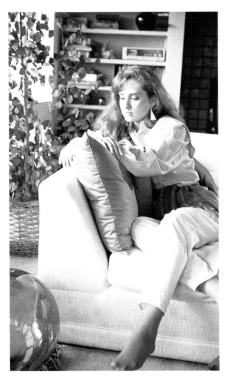

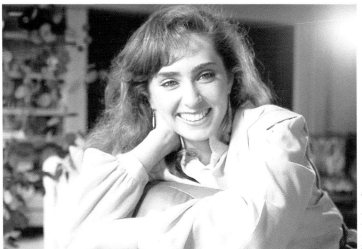

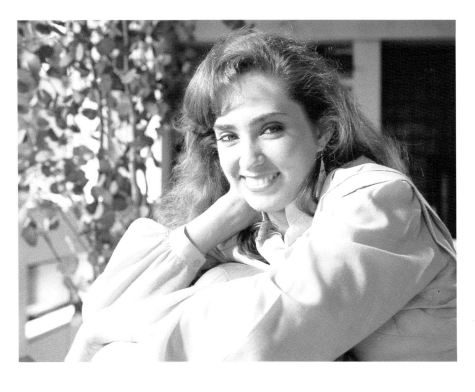

Photos by Lynn Powers

Above, the basket of branches and the glass fishing float are unrelated and distract from the subject. At top right, the foreshortening of the model's arm makes this pose undesirable.

This is it! The position is natural and easy to reassume. The leaves and branches in the background create visual entertainment but do not overwhelm the subject. See the painting demonstration on pages 94-99.

Observing Your Subject

After you've made the decision about what to paint, it's time to carefully consider your next move. In portrait painting, this process begins with a critical observation of the model. By taking the time to *really look* at the model, it's possible to see things you may have missed at first glance, and perhaps, prevent a few "I wish I had" complaints later on.

For instance, the way your model is lighted should be observed carefully. Take a look at the photo of Pat (page 35) that we have chosen.

The sunny side is clearly visible (A), as are the somewhat cooler areas turned slightly away from the direct sunlight (B). The shadow side is full of color. The cast shadow on the model's forehead (C) is dark just under her bangs, becomes lighter, and then darker once more as it turns into the shadow side of her face (D), only to turn light again near her hairline (E). The color at her temple is somewhat green. Follow the hairline down her cheek, and the color seems to turn warmer, more toward orange (F) near her ear. That is the reflected light bouncing off her left shoulder. You can see that same glow of reflected light under the edge of her nose and under her chin (G and H).

Pat's hair can be described with a great deal of color. It appears greenish

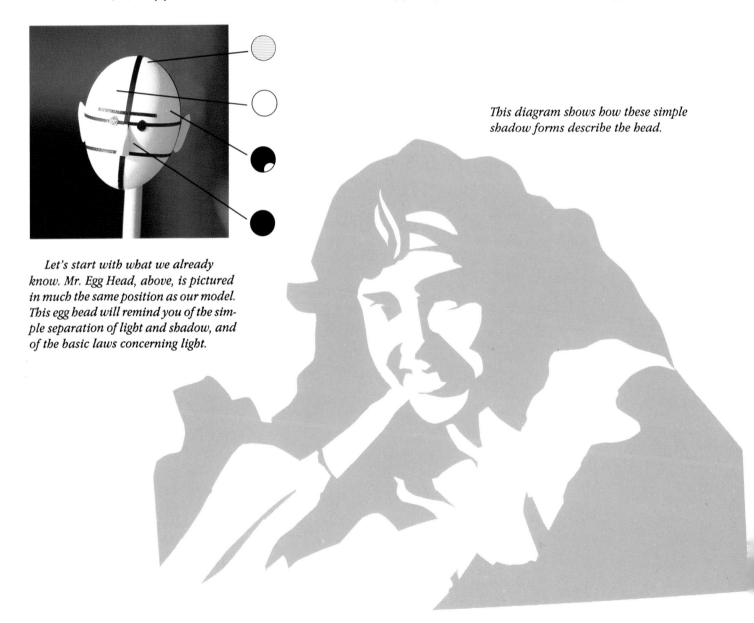

Let's start with what we already know. Mr. Egg Head, above, is pictured in much the same position as our model. This egg head will remind you of the simple separation of light and shadow, and of the basic laws concerning light.

This diagram shows how these simple shadow forms describe the head.

gold in the sunshine (I). The top of her hair is cooler blue-green (J). This is in keeping with the laws of light that say all horizontal surfaces are cooler than vertical ones in full sun. Isn't that red glow at the back beautiful (K)?

How about the "underneath darks"? This warm color is to be found under her (L), in the corners of her mouth (M), and in several other dark recesses.

Study the folds in the sleeves. You will see shadows (N), cast shadows (O), and reflected light (P) appearing next to one another, creating a myriad of subtle color. There is more to see, so keep looking. Some of the color described here may not be visible in the illustrations, given the limitations of the color printing process; however, a great variety of color *is* there to be seen in life. (Interpret it the way *you* see it. You know where to look; it's up to you to find it.)

As you study Pat's face, try to think of shapes—the side of her nose, the curve of her cheek, etc.—as visible evidence of the underlying structure of the skull and the muscles over it. These shapes identify a particular head, and are the basis for the modeling to follow. Include as much information about the location of these forms as you are comfortable with. Study the sketches of Pat on page 94.

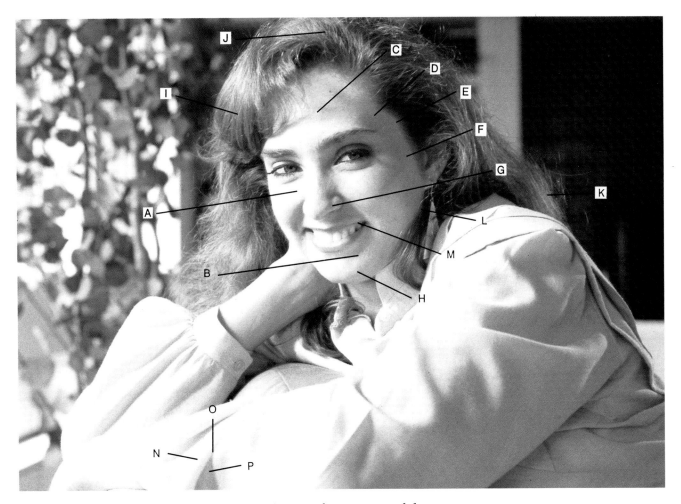

Study this photograph of the model, Pat, and refer to it often as you read the text above. This will help you discover the range of colors present in even the simplest of outfits and backgrounds.

Arrange the pose, adjust the lighting and plan your color scheme; then you're ready to start painting. The first step is the undertoning.

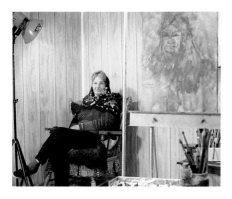

When the undertoning is dry, sketch in the figure so you'll know where it will be on the canvas.

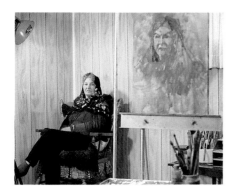

Next, block in the light fleshtones. Try to indicate the basic pattern of colors and values quickly, during the first twenty-minute pose.

Designing the Portrait

The most important part of your painting isn't the model, but the whole concept—not a part, but the whole. Don't get hung up on the traditional pose—model in a chair. As you pose the model, think of placing him or her at different angles to the light source in order to create interesting light-and-dark patterns on the face and figure. To pose the model in a more relaxed position, try turning the lower body slightly in one direction while turning the upper torso a little in the opposite direction, allowing the head to slant a bit, too. Those angle changes help your model look natural. A very straight pose tends to look stiff or awkward.

One additional tip: When drawing your model on the canvas, exaggerate the angles, because there's a natural tendency to paint the figure stiffer than you see it. Exaggerating helps alleviate this stiffness.

Props help make a situation more interesting. Tables, chairs, vases and hanging objects all help fill a negative space. Remember: Select props that complement the expressive mood you want to create with a model.

Since props include clothes, collect interesting garments, by going "sailing," that is, "garage sale-ing," or shopping at thrift stores.

You should carefully consider the backdrop or background as well. The color and value will have a strong influence on how you see and paint all the other values and colors in your setup. Drapes of varying color, value, pattern and texture are a good choice for a backdrop. They provide an appropriate setting for the figure without calling attention to themselves. Begin collecting old curtains, sheets, even rugs for this purpose. Choose the color and value that work best with the overall tonality and color scheme you have selected. For instance, don't use a red drape if you plan to paint a cool background. That would be an impossible problem even for the most trained painter.

Take the time to plan color harmony. Make sure you have worked out the analogous colors you intend to use before you paint. *Now start.* Call your model to the stand and get going.

Use a large brush to establish color and value. This procedure takes about five minutes, providing you have paints on your palette and everything else at hand.

If you use acrylic for your underpainting, you're ready to start applying oil pigment as soon as your canvas is dry to the touch. The underpainting is meant to eliminate guessing as to where the model will be placed on your canvas or what your color scheme

is. It's not necessary to cover every inch of the canvas with oil overlay. Many times, a bit of acrylic peeking through is exciting.

When the model is taking the first twenty-minute pose, work fast to indicate the placement of the model and the nearby objects, quickly working out the design or composition. Keep this step somewhat abstract. Now give your model a rest and let him get off the stand to stretch his legs and back. Mark the spot where his feet are with either chalk or a bit of masking tape, and also make sure he remembers where and at what he was looking.

With the model back in the pose, continue to relate what you see with what is already suggested on the canvas. Check your drawing, concentrating on the correct features and anatomy of the figure.

With a correct drawing and the color scheme and design well worked out, proceed to bring areas of the painting near to completion. This step can take varying lengths of time since you're dealing with subtle value changes.

Keep your brushstrokes fluid and loose so they never become overworked at any stage. Think of the model as shapes of color and value — and have fun.

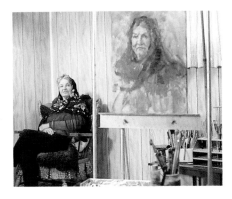

Continue to suggest the larger pattern of lights and darks, comparing your painting to the model.

In the final step, refine the details or add subtle touches. Notice that the areas around the face are looser and less detailed, so the focus is on the face.

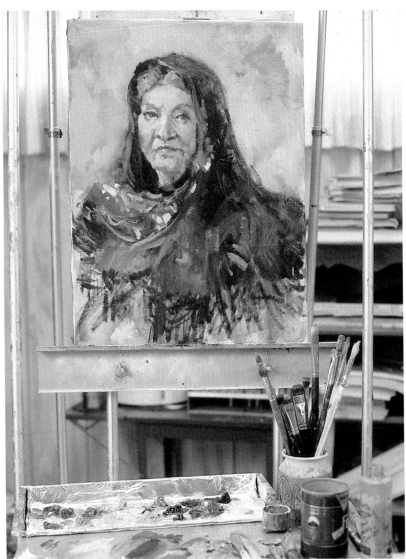

Señora Jessie
24″ × 18″
Joyce Pike

Portraying Personality

Avoid a typical pose whenever possible. If the pose is either stiff or uninteresting, the painting will lack the excitement every painter should achieve. Use the same concept for setting up your model as you would for a still-life arrangement. Balance your objects, including the model, in a pleasing pattern of light, dark and color. Design is the work. Think shapes only. The model is part of the whole concept, and how you integrate her with all the elements can make the final image exciting or boring. To make the painting work for you, you may want to incorporate the personality of your model in a situation pose. When you plan a portrait, also think about related background objects. You may be requested to use specific objects when you do a portrait commission. These objects should relate to the interests and character of the subject.

The painting of Carolyn, below, was conceived in just this way. The lamp and the painting in the background were positioned for balance, but selected to establish historical authenticity. It's exciting to take an old object and make it come alive on canvas.

Carolyn is a quiet, dignified woman, and these objects, as well as the color harmony, mirror these traits.

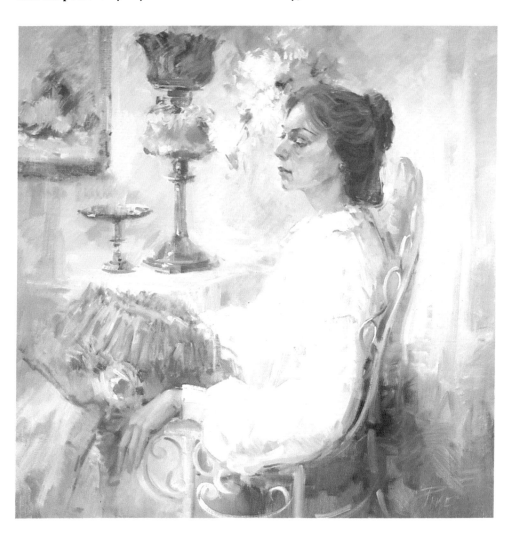

Carolyn
30" × 40"
Joyce Pike

Carolyn is soft, delicate and petite. It was easy to place her in these surroundings, as her clothing and hairstyle were obviously from a bygone era.

Basic Portrait Techniques

Telling a Story

Situation poses—ones that tell a story—can be intriguing. *Woman at the Well* is a biblical story. It required a model who was beautiful, with expressive eyes.

The same procedure was used to secure the color and composition here as for the portrait of Carolyn. The dark background in the low-key painting brings out the model's beautiful blond hair and fair skin. The undertoning was mostly blue and violet with touches of green. A touch of alizarin crimson was scumbled throughout the dark background to keep it from becoming too solid and dull. (Remember: A little alizarin crimson goes a long way.) The water urn was sap green, and cadmium red light with ultramarine blue was used for the dark shadows. The urn is dark for design balance. The warm fleshtones complement the cool blue-violet dominant hue, and the blue-violet shadows of the blouse tie in with the background tones. The highlights of the blouse were painted a warmer hue than in real life to make the large white mass of the blouse area exciting and to minimize its stark whiteness.

The hair will work best if it is the same mixture that is used in another part of the painting. For instance, the shadow side of the hair is the same mixture that was used for the urn, while the lights in the hair are almost the same mixture as was used for the fleshtones.

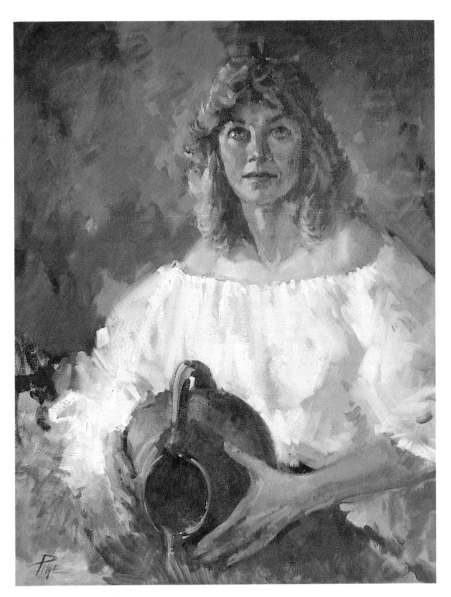

Woman at the Well
30" × 24"
Joyce Pike

With just a little imagination and some well-chosen props, you can convert a pose into a story. The model's beautiful, expressive eyes were just right for illustrating a dramatic incident from the Bible.

Character Studies

Quick studies are great fun and great practice. They can be even more fun if they are also character studies. Often when you're working quickly, you can capture character and personality more easily, perhaps because there is less concern for photographic accuracy and more attention to the qualities that make the sitter a unique individual. These studies will often turn out better than something you labored over. This painting of the old sea captain started out to be a preliminary study for a painting. An old canvas was covered with just enough white paint to plan the head study and not be confused by the old paint already on the canvas. Using direct, loose brushstrokes, the composition and color were quickly worked out, keeping everything in gray except the fleshtones. Since the face

was painted with more vibrant color than actually existed, a rosy glow is apparent. The grays that dominate the entire painting remain warm, with touches of orange complement showing through in the jacket area. The overall warm glow makes the painting hold together. Plan color for every composition, even when painting in gray, as in this sketch.

Tim Padilla posed for the painting entitled *The Sheriff*. He was a much sought-after professional model. Every school of art in California put him at the top of their list. He may be gone now, but he will continue to live not only in the hearts of those who knew him, but through the many paintings

done of him by many great painters—what a legacy! There are great models, but none greater than Tim.

The first step was to capture his personality. Red was used in both the shirt and the face, with a bit scumbled over grays for the background. The hat was a mixture of the three primaries, with a bit more of the yellow. The vest was painted with sap green and cadmium red light, with a bit of the same mixture used in the shadow area of the hat. The underside of the brim reflected orange and red from the shirt. Tim's white hair and beard were almost violet in shadow, with many subtle variations. A warmer tone was used where the light struck the mustache and hair.

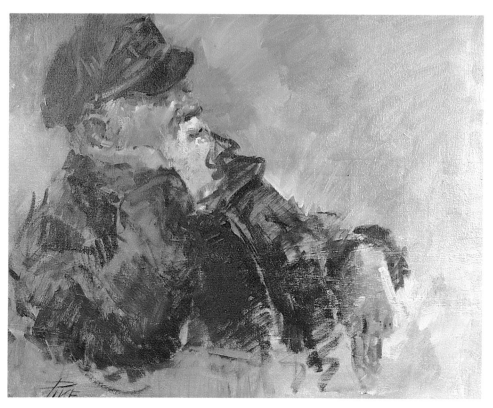

The Sea Captain
24" × 30"
Joyce Pike

Quick studies are great practice. Although this painting of the sea captain was done on an old canvas as a preliminary study, it proved to be a more effective painting than the finished version.

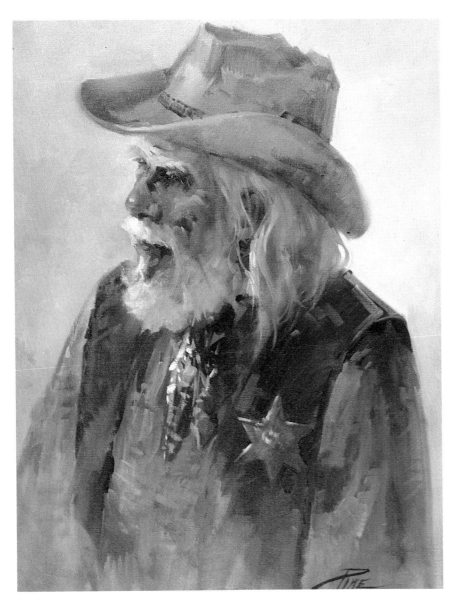

The Sheriff
24" × 18"
Joyce Pike

This sketch was done in one sitting. Tim had strong bone structure and smiling eyes.

The detail shows the loose brushwork on the face and head. You can almost count each stroke. Notice how they all add up to a convincing portrait with a great deal of character.

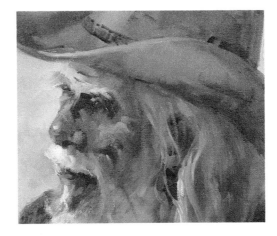

Posing Children

As have all portrait painters before you, you'll have to use your ingenuity and think of ways to keep young sitters in the same room with you. Keeping them looking at you takes even more cleverness. When work actually begins, the best thing you can do is talk with the child. Let the parent be there, but in the background. You'll find it absolutely essential to talk with your subject. If you don't, you'll find he either falls asleep or escapes from the chair. The idea is to get the child talking so you can just nod or smile and concentrate on your work. Try opening the conversation by asking about a pet, or brothers and sisters, or a favorite TV show or even a favorite color. In short, ask the child about himself. Incidentally, this technique works just as well with adult sitters.

Once in a while, you'll have a youngster who will sing for you. You can have fun with this, especially if you know the songs, too, and sing along with him. Background music helps everyone relax and fills in the gaps when there is no conversation. Some parents bring the child's favorite tapes along. But insist on absolutely no TV! Television may keep a child in one place, but that mesmerized expression is too unnatural for a portrait.

If you work standing up, you'll have to raise the child to your eye level. Try a tall stool with a back on it that rotates—children really like that. If a child gets fussy, she might sit on the lap of the parent who agrees to sit on the stool. If you're desperate, it's sometimes just easier to get down on the floor with the child while she sits in a juvenile chair or plays on the floor with her toys. Of course, this means moving all your painting gear to the floor, too.

Some youngsters will be doggedly determined to get into your paints and may even want to work on the portrait. No matter how nice you want to be, don't let this happen. If you allow the child to dab around with the brush even once, you'll find that your subject will want to paint, not pose, and you will have lost control of the situation entirely.

Very Young Children

For young children, keep a box full of trinkets, little cars, games and mechanical puzzles. When the child is obviously getting bored, put the box on a table in front of him so he can pore over its contents. Jewelry is a great idea for girls—as they try on the earrings or necklaces, they will look up at you for approval. Thrift shop jewelry is fine; anything that sparkles will do. If you want to make a friend for life, let the child choose one thing to take home and keep each time they come to pose. You can keep your model with you a little longer while she tries to make the perfect choice.

After you get the hang of it, hand puppets worn on your nonpainting hand are terrific child-pleasers. Playing peekaboo—popping out from behind your easel—produces a marvelous expression of gleeful surprise on a very young face. John Singer Sargent used to surreptitiously dab red paint on his nose when he needed to get that one last look to finish the portrait. The child would say, "You have paint on your nose!" and the artist would reply, "Oh, you must be mistaken, *I* would not have paint on my nose!" And the child would say, "But you do, you do!" This conversation would go on long enough to allow Sargent to catch that eager expression, that one last look we always

need. Painting a mustache on your face would work beautifully.

After a while, many children will ask, "When will you be done?" or complain, "Aren't you done yet?" When it looks like they are about to run out the door and you need more time, let them wear your watch and tell them they can get down when this hand gets to that number. This works far better than telling the child you only want her to pose "for about ten more minutes," because children have no idea how long ten

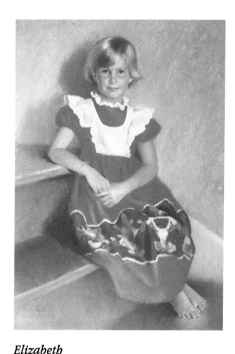

Elizabeth
28" × 22"
Roberta Carter Clark
Pastel on sanded pastel paper
Collection of Mrs. Nan Hewson

Elizabeth's Colonial house was surrounded by trees and had no place light enough to work. At last, for additional light, the front door was opened, and Elizabeth sat near this natural light on the lowest steps of the staircase. This gave a natural and graceful pose.

minutes is. Most children enjoy this game, especially when they see that the hands really do move and thereby realize that you are not just humoring them. They are amazed that you would give them your watch to wear, too. But you better have an inexpensive watch—you can't get mad at your model if he throws it.

Never forget the allure of animals. Somehow children and dogs form instant friendships that keep subjects in the studio a bit longer—and every minute helps. (Of course, if the child is allergic to dogs, forget this.)

Most anything goes for about an hour, but if your subject looks tired, or not well, or begins to cry, don't push him. You will be able to sense when the visit is over. You want the child at his best, and if his eyes are drooping from exhaustion, or glassy from a cold or a fever, or red from crying, there is nothing more you can do that day.

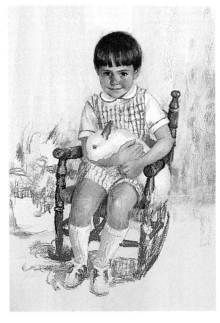

Jake
28" × 22"
Roberta Carter Clark
Pastel on buff sanded paper
Collection of Mr. and Mrs. John C. Pettit

The bunny adds interest to this portrait and contrasts with Jake's dark hair.

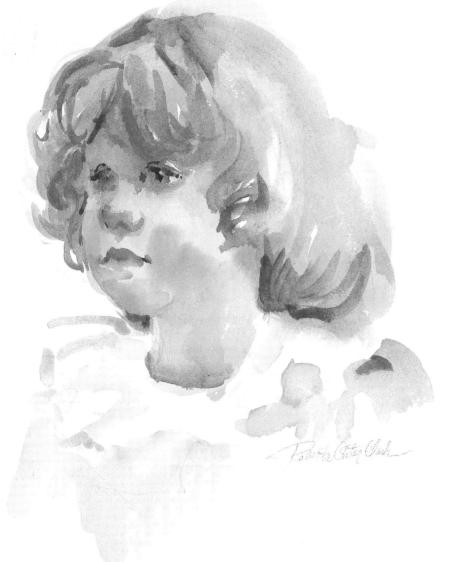

Janell
14" × 22"
Roberta Carter Clark
Watercolor on Arches 140-lb. cold-press paper

Janell has a serious little face. She was about four years old, and this watercolor portrait sketch was the result of twenty minutes of posing.

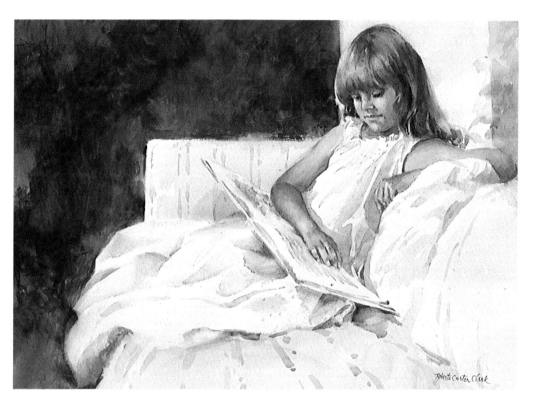

Older Children, Ages Six to Twelve

No one really *loves* posing, but children are quite pleasant about it, for they want to please their parents, and they more or less relax into the routine. Keep a kitchen timer at hand, and when the young person starts fidgeting, set it for twenty-minute poses with five-minute rests in between. However, don't use the timer until you absolutely need it. It's distracting for the child and even more so for you to be always working against the clock.

At this age, children love riddles and jokes, and it is a good idea to keep a couple of riddle books around the studio. They also like to bring a friend when they pose—a very good idea sometimes (not at the first sitting, though). You will see the young person in an entirely new light with one of her peers, and the more they talk, the easier it is for you to concentrate on your work—that is, unless they keep you laughing so much you can't continue. Some people this age are true comedians. Usually one visiting friend at a time is enough; a whole group can create havoc.

Snacks and beverages for the breaks between posing are essential for these kids, especially if they come after school. They are always hungry, and food seems to give the sitting more of a party atmosphere.

Kelly
22" × 30"
Roberta Carter Clark
Watercolor on Arches 140-lb. cold-press paper
Collection of Dr. and Mrs. John Madsen

This watercolor was painted from photographs, a useful tool for the artist painting a portrait of a young child.

Young People, Ages Thirteen to Sixteen

Teenagers are marvelous to paint, for they are enigmas, neither children nor adults. This group presents a genuine challenge for the painter: to portray the subject's actual age. Also, they are so attractive you can make terrific paintings of them. No need for flattery here; you can paint them just the way they are.

If you take your time with these young people, you can become fast friends. Let them talk, and you listen. They are often intrigued by your ability and interest in art, and they shine when they realize you are interested in them. *Never* criticize anything a teenager says or does or expresses an opinion about. You can't even look shocked; they may be testing you by saying something outrageous. And let your teenage model choose the radio station you listen to while working.

Lisa
68" × 36"
Roberta Carter Clark
Oil on canvas
Collection of Mr. and Mrs. Niels Johnsen

Lisa was fourteen years old when this was painted. The family had just moved into a new home with soaring ceilings, so the portrait had to be large.

Alec
30" × 36"
Roberta Carter Clark
Oil on canvas
Collection of Mr. and Mrs. Frederick M. Genung II

Alec was a very athletic twelve year old, and he had so much energy he could not sit longer than twenty minutes at a time. The football was very special to him and had to be rendered just so, signatures and all.

LIGHTING THE PORTRAIT

How Shadows Create Form

Here is the egg head again, along with some simple watercolor sketches to illustrate how information concerning light and shadow can prove useful to you when you're painting a head. These sketches have been marked with symbols (refer to the egg head for the key), so you can see how each facial area conforms to the "laws of light." These laws state that horizontal surfaces reflect the sky and are therefore cooler (bluer) in color. Surfaces facing the sun will be warmer (yellower) in color.

Notice the places where the sunny and shadow sides meet. This area is oblique to the sun and is therefore somewhat cooler in hue.

With careful observation, the changes in color temperature on objects viewed in the sunlight will become increasingly apparent.

No matter what subject you are painting—portrait, landscape, still life, or whatever—the shadow side will always be 40 percent darker than the light side. It may also receive reflected light (and color) from a nearby object (such as clothing).

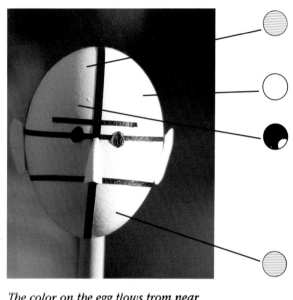

The color on the egg flows from near white (toward orange) to a cooler shade as it approaches the shadow side. The shadow side is 40 percent darker than the sunlit side and may contain reflected light. There is no reflected light in the cast shadow.

In this watercolor sketch, the head looks a great deal like the egg. The flesh color (yellow-red) has been "cooled" with the addition of alizarin crimson as the face curves away from the direct sun.

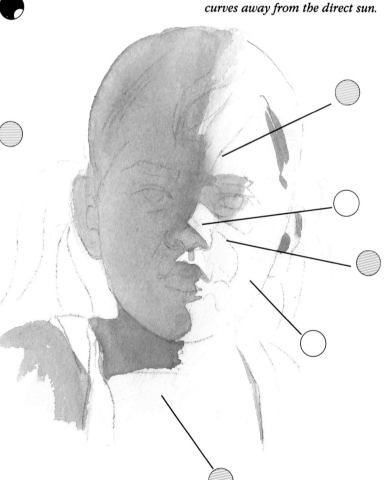

Basic Portrait Techniques

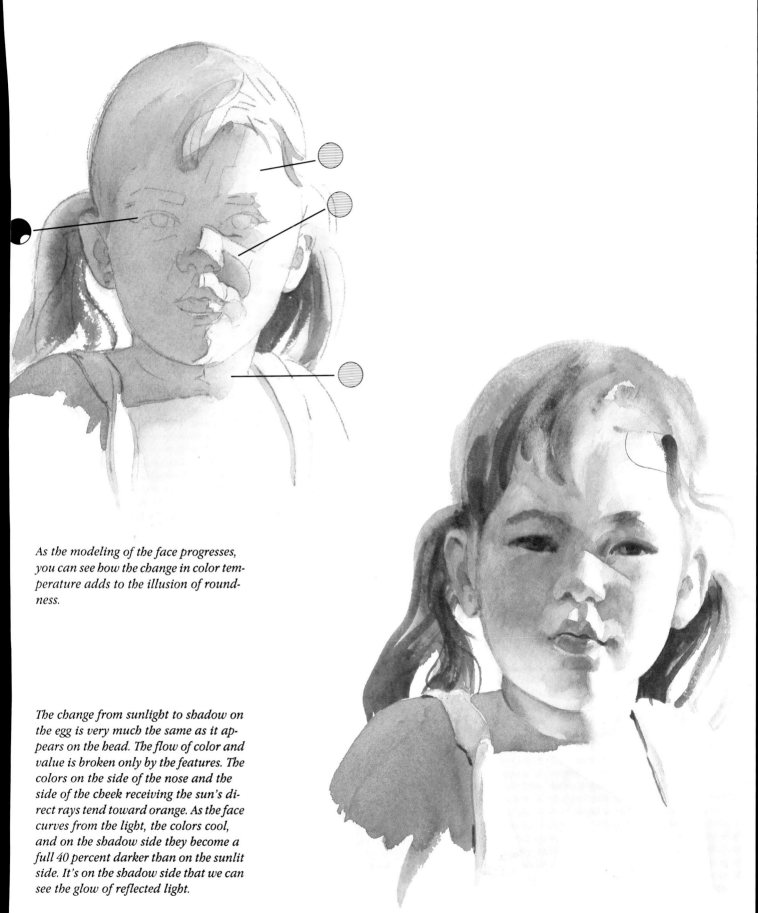

As the modeling of the face progresses, you can see how the change in color temperature adds to the illusion of roundness.

The change from sunlight to shadow on the egg is very much the same as it appears on the head. The flow of color and value is broken only by the features. The colors on the side of the nose and the side of the cheek receiving the sun's direct rays tend toward orange. As the face curves from the light, the colors cool, and on the shadow side they become a full 40 percent darker than on the sunlit side. It's on the shadow side that we can see the glow of reflected light.

Light Reveals Form

Every form we see, including the human head, is revealed by an arrangement of different surfaces. Light reveals form by the way it illuminates these surfaces. The more fully exposed to light a surface is, the lighter in value it becomes. As the surface turns from the light, it darkens and eventually recedes into shadow.

Light must come from a definite direction to clearly show form. With one common light source, all the different surfaces of a subject can express their true relationships to each other, and the subject's form will begin to show.

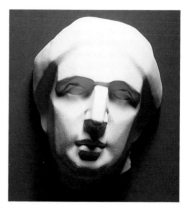

When light comes from one direction, surfaces that receive the most light are lightest in value, and others become darker and recede into shadow as they turn away from the light. The middle range of values is necessary to show this modeling of form.

The Tonal Value Scale

Dark values emphasize underlying structure. *Middle values allow subtle modeling.* *Light values show the direction of light.*

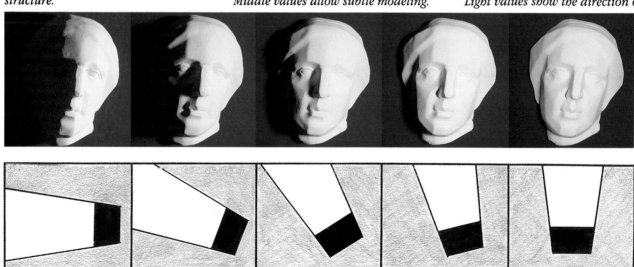

Light must come from one definite direction to show full form. As the light source or direction changes, value arrangements will also change on the subject. The shape of dark-and-light areas will change in proportion to the changing light direction. Middle values may become more important as they begin to show subtle modeling of surfaces.

Light and the Head

As light strikes the surfaces of the head, some of them remain fully in light and some go into shadow. This creates an arrangement of dark and light values. Surface forms are seen and identified because different dark shapes and edges become visible. In light coming from a definite direction, each part of the human head has its own distinct value shape and edge. As the light changes, there will be a corresponding change in value shapes and edges.

Edges are an important way of identifying the head. Some edges are sharply defined and show abrupt changes in a surface. Other edges are softer and show gradual changes, such as those that occur on a curved surface. Middle values connect the darker and lighter values and give continuity to the whole value range. They help show the full effect of form by depicting how a surface changes. Depending on the surface form itself, they can be large or small in area.

Cast shadows have well-defined edges. On facial features, cast shadows merge with other darks to help identify form. On pages 50-53, we'll see how lighting direction affects the appearance of a portrait subject in a variety of poses. Familiarity with these lighting effects is important for painting good portraits.

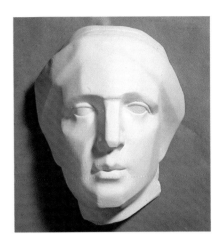

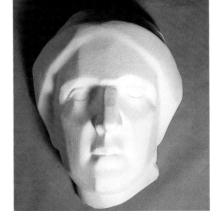

Light coming from one direction shows surface form by the light-and-shadow areas it creates. If the light direction changes, the amount of light that a surface receives will also change. Some areas become darker, while others become lighter. A significantly changed light direction will completely change the appearance of the head.

Detail of Barb
16" × 20"
Ted Smuskiewicz

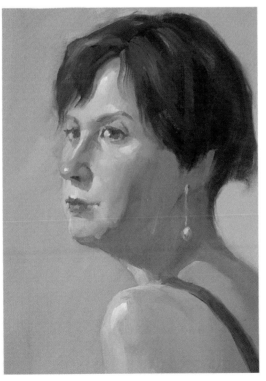

Flesh colors appear warm and rich under a warm light; shadow areas look cool and gray. Always keep in mind the color or temperature of light when mixing flesh colors.

Studying Light Direction

As you've seen in the previous pages, the way you pose your sitter in relation to the light source has a great bearing on the look of the finished portrait. When posing your model, lighting is the first thing to consider. Many artists use natural daylight or daylight supplemented by artificial light. Some find it impossible to paint fleshtones at night when the only available source of light is artificial. Of course, artificial light is fine for charcoal portraits, where color is not involved.

Before you begin to paint or draw, try having your sitter pose with several different lighting arrangements and in different positions. Usually one place and one pose will be so much more interesting or beautiful than the others that you can hardly wait to paint it. That's the one to choose.

On the following pages, you'll find examples of various poses of the head and ways of lighting it. Draw these photographed heads, then try to simulate these poses and lighting conditions on your own, with a model, and make light-and-shadow sketches of each of these. You will learn a lot from this.

Lighting the Front View

Let's study the way lighting affects the portrait subject. You'll need someone to pose for you. Your drawing materials include paper, a soft pencil (perhaps a 6B), a kneaded eraser, and some sort of portable spotlight such as a clamp-on type or a photographer's light and stand—even a table or floor lamp with the shade removed will work. A 200-watt light should be sufficient. Draw your model in the kinds of light discussed here. He or she should be looking straight at you.

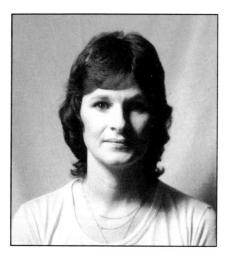

Rembrandt lighting: The lamp is at about ten o'clock, slightly to the front. A triangle of light appears on the cheek *away* from the light source. This type of lighting describes form very well.

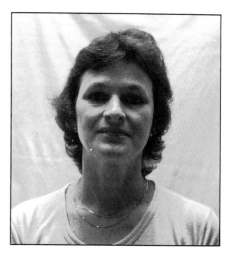

Overhead light: This makes large, dark holes for eyes and is most unflattering. Often an overhead skylight creates this effect. Very satisfactory, if you like a *spooky* portrait!

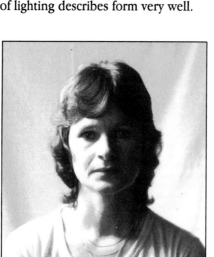

Sidelight: One side of the head is in the light, and the other side is in shadow. Sidelight is highly dramatic but unsuitable for natural-looking portraits.

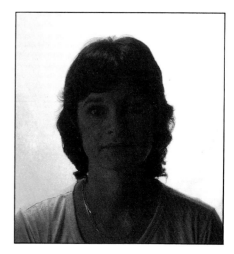

Backlight: This creates a silhouette—it's what happens when the model is in *front* of a window. Backlight could be interesting to use if some light were reflected back into the face with a mirror or a piece of white cardboard.

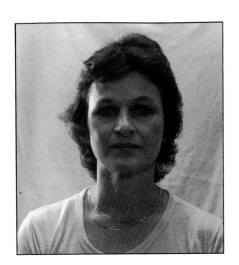

A *word of caution*: When using artificial light as a supplementary source of light, be extremely careful not to get "crossed" lights—that is, one light coming from the left and another of the same brilliance, from the right. Should you ever find yourself in this crossed-light situation, your work will end in complete frustration. Remember, one source of light *must* dominate. Make sure the second light is not as bright as the primary illumination.

Three-quarter backlight: This rim light is interesting for unusual faces, but too harsh for some. It's not for conventional portraiture.

Bottom light: It turns any face into a fearsome one—you really have to see it to believe it. Try it on yourself with a lamp or flashlight.

Frontal light: Since it's nearly shadowless, frontal light is excellent for people over thirty-five. The features are clearly described, but none of the aging characteristics are emphasized. It's also good for children, since it's best to aim for natural effects rather than theatrical ones when painting them. The eyes show very well in this light, as does soft, delicate modeling. If you stand with your back to a window, both the sitter and your canvas will be bathed in this frontal light—a good arrangement.

OUTDOOR LIGHTING

After you've been working for some time, make a conscious effort to vary the lighting schemes in your portraits. Some painters use the same light direction in all their work, and this sameness has a tendency to make all the portraits look alike. One interesting variation is to make the person appear as if he were outdoors.

To do this, try using a diffuse light. There are two ways to diffuse the light. You can place the light farther away from the subject or place a diffusing shield over the spotlight. In nature, the light comes from the sky, but it is reflected in a hundred ways; it is a flattering light for people of any age. Almost all portraits with outdoor backgrounds and light were actually painted indoors. Try painting your subject in the open air just one time and you'll know why. The flickering of light through leaves constantly moving in the breeze, the lights and shadows on the face changing every half hour as the sun moves across the sky—all this can make your job frustrating.

However, if you decide you absolutely must try it—and you should—be sure to keep the sun off your canvas or paper when you are painting. It's impossible to judge the true color of things when the canvas is reflecting sunlight into your eyes. The same rule applies to landscape painting. However, you must realize that the more landscapes you paint outdoors, the more convincing the "outdoor daylight" in your indoor portraits will be.

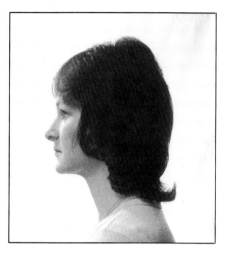

Top front lighting: Positioning the light at the front of the face and slightly from above, at about ten o'clock, is a good angle here.

Rim light: This general, overall light coming from the front makes for an interesting profile portrait. Moving the light source away from the face creates a softer effect.

Back rim light: This really describes good features. Unusual.

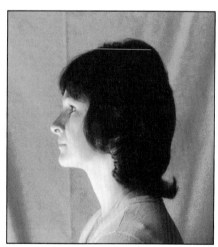

Total frontal light: This light isn't very satisfactory for a profile portrait. The portrait always appears somewhat flat, as it shows only half the face and one eye. Frontal light flattens out all the forms even more.

Bottom light: Scrooge and evil spirits once more!

Lighting the Three-Quarter View

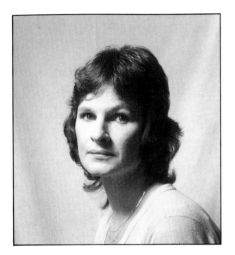

When the model is seated close to the light source, we get a very intense light — too intense for most portrait clients but really exciting for the painter because of the distinct lines of demarcation between light and shadow areas. The lighting is excellent for the study of solid form.

Rembrandt lighting: Creating a triangle of light on the cheek of the shadow side of the face is the most dra-

Here the model is seated a bit farther away from the light source. We get a softer light, with less contrast, but still quite good definition.

matic and most definitive of all lighting. Here are three versions of this time-honored lighting for portraiture.

The model is even farther from the light source here, giving us a very soft, quite diffuse light. This version is more flattering for the portrait client, but it's more difficult for the painter because of such subtle definitions of forms.

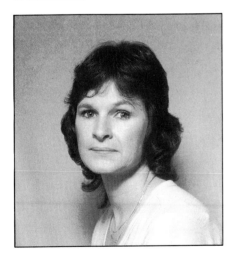

Frontal light: This light diminishes all shadows; therefore, it is most flattering for women, and in fact, for anyone past middle age. It's good for children as well, particularly since children's faces are best painted without heavy shadow areas.

Rim light: This light is good used as an accent light when the general overall light comes from the front. It is often seen when the subject is near a window on a bright day.

Building Form With Paint

When you begin to paint, paint as if you were modeling every brushstroke. Let each stroke mean something and add to the painting's effect. Model form with paint by first beginning with good tonal value control. Only the strength of darks and lights can construct the full shape and depth of form. Good color is first built on a solid tonal value foundation. As color changes begin to show form, tonal value changes are also helping.

When making brushstrokes, think of the way the surface is going and paint in color to suggest the surface itself. Don't always brush your colors in the same direction, but let the form guide your brushstrokes.

By applying your colors with the right kind of brushstrokes, form can be suggested that has more than just color. It can have depth and dimension, too.

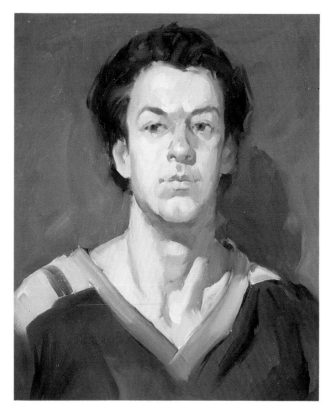

Portrait Sketch
Ted Smuskiewicz

This tonal painting shows the power of using only value to show form and a sense of light.

To block in this hand, dark-and-light tonal-value construction, color-temperature control, and direct brushstrokes were used. The highlights on the wrist were brushed in strongly compared with other longer and softer strokes that shape the hand. The deep crimson color brushed directly against the outer edge of the hand helps define the shape.

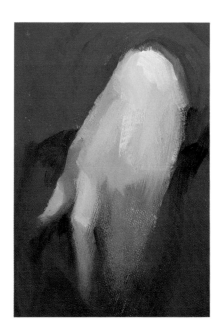

Look at the way form in the eye and nose emerges with several well-placed brushstrokes. Always think of how brushstrokes can be used to build a certain form.

Before adding finishing colors to develop form, lay in some solid masses of color that describe the basic shapes. Here, darker yellow colors were used for the first basic shape. The background color is painted directly against the hard hat's yellow color, then highlights and other strong accent edges were added.

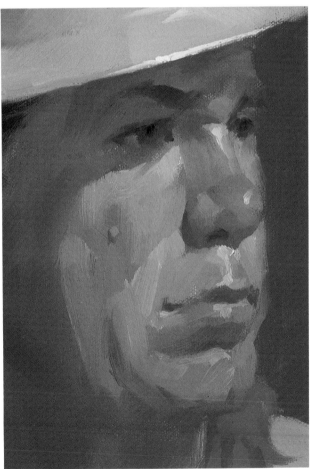

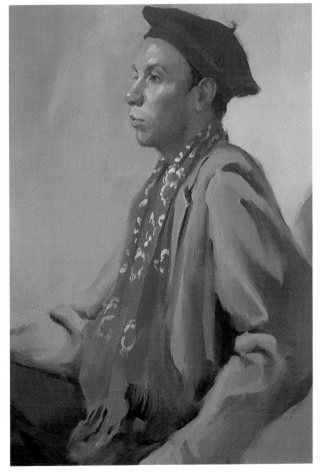

Detail of Man in Hard Hat
16" × 20"
Ted Smuskiewicz

Notice how brushstroke directions add to the effect of surface change on the face. Pay attention to edges. Without good edge control, it is difficult to model form. Color-temperature control is also important, as it can help show subtle surface changes.

Detail of His Red Scarf
20" × 24"
Ted Smuskiewicz

The form of the sleeve is brought out by a combination of directional brushstrokes and solid dark-and-light construction. The scarf is first painted with dark and light values to show its form. The light design is then worked into it, guided by value changes in the surface.

Color in Different Light

Every kind of light has an individual color quality. Therefore, the color temperature of the main light source is an important part of a painting.

Light is either warm or cool. Light leans either toward the yellows and reds or toward the blues of the spectrum. A warmer light can appear more yellow, orange or red, while a cooler light can have more blue, green or violet in it.

Because light carries its own colors in it, anything it strikes will be influenced by those colors. A warmer light toward the yellow side will make a green color look yellow-green. That same green will look blue-green under a cooler light that has a lot of blue in it. Sometimes, to achieve a different color effect in a painting, an artist will purposely change the color temperature of the light.

Warm Light

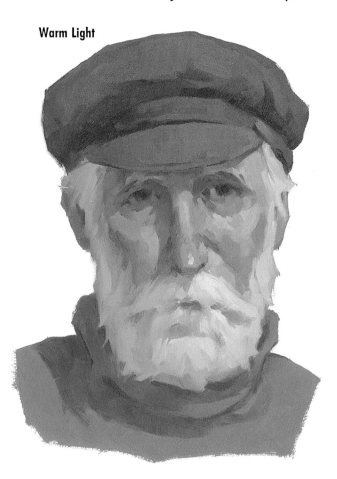

Under a warm light, local color (actual color) in a subject is influenced by the yellow and orange in the light. In warm light, darker shadow areas look cooler and grayer than the lights because the subject's form blocks the warm light from these areas. The uniform color influence from the light throughout the subject helps to hold together all the different colors.

Under a cool light, blue and blue-violet are influencing the local colors of this subject. Notice the differences in color in his brown cap, blue sweater and gray beard. With a very cool light, darker shadow areas tend to look grayer and slightly warmer than the lights. Colors will generally look brighter in light areas because there is more light illuminating the surface.

Cool Shadow

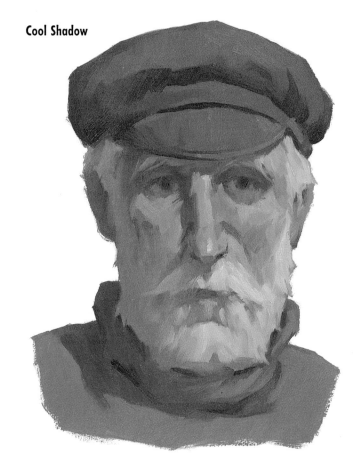

Basic Portrait Techniques

Color Temperature and Form

Through direction and color temperature, light shows us the form of a subject. One main light source striking the many different surface forms creates various dark and light values that help show form. When color temperature influences these values, additional information is given that can strengthen the modeling of form. With a warm light, surfaces that are receiving light are lighter in value and warmer in color than those surfaces that are between light and shadow. Since warmer colors come forward when placed next to similar colors that are cooler and grayer, a feeling of space and distance is given to a form by using different color temperatures.

The best way to learn to see the difference in color between varied light sources is to paint the same subject in different types of light, for instance, by an ordinary household incandescent lamp, by the natural daylight coming through a window, and in a cool fluorescent light. Squint to see correct dark-and-light value relationships.

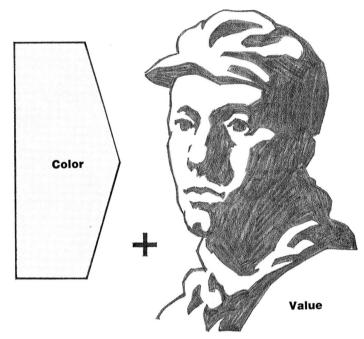

Color + Value

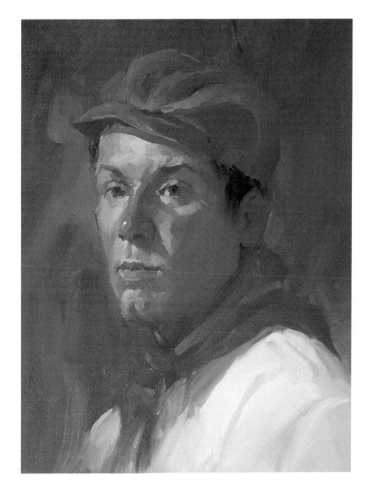

Lucian With Red Scarf
14" × 18"
Ted Smuskiewicz

Warm light creates a strong contrast between light and dark. As colors on the different surfaces turn from light into shadow, they darken in value and become grayer and cooler. Changes in value and color temperature are used in this painting to model form and create the effect of a strong, warm light.

PAINTING BACKGROUNDS
Helpful Methods to Explore

Many students complain about the difficulty of painting backgrounds. This is because they often ignore the first rule about backgrounds, which is: *Paint the background right away*. Commit yourself to the background at the beginning of the painting process. Don't put it off until the end of the painting! Remember this negative rule: If you want problems painting backgrounds, paint them at the end of the painting process after everything else is completed. It never works. A background painted at the end of the painting process alters or destroys all the previously resolved color relationships. This happens because we judge colors in relation to the colors surrounding them. If you paint a head study without a background, you will select colors that look good against the natural color of the board or paper.

Later, if you fill in the background, you'll change how all the other colors look because you have surrounded them with a new color. In addition to changing the color relationships, adding a background later also changes the value relationships in the painting.

This background problem is unique to portrait painters. Artists working in other genres compose their paintings from side to side and top to bottom as complete entities from the start, but we portrait artists are interested only in the person sitting for us. You have to discipline yourself, but you'll be much more at ease if you plan the background before you begin to paint.

Some artists solve this problem by painting their backgrounds a plain solid color without much variation. There is no doubt that this concentrates the viewer's attention on the person portrayed, for there is nothing else to look at in the portrait. It's a safe approach, but the flat color does tend to flatten the painting. If you want to use one color, you can achieve more depth by varying the values, painting part of it dark and part light.

Start thinking about and studying backgrounds. Look at the backgrounds in the portraits in this book. Then look at other art books or at portraits in a museum. Because the artist purposely designs the background so you will not notice it, you usually don't. When you want the backgrounds in your portraits to be better integrated with the figure, or to set it off more, you will start to notice them. The only rule that matters is that backgrounds must recede. One way or another, the background must read as if it were behind the subject.

Stephen
30½" × 24½"
Doug Dawson
Collection of El Paso Art Foundation,
Colorado Springs, Colorado

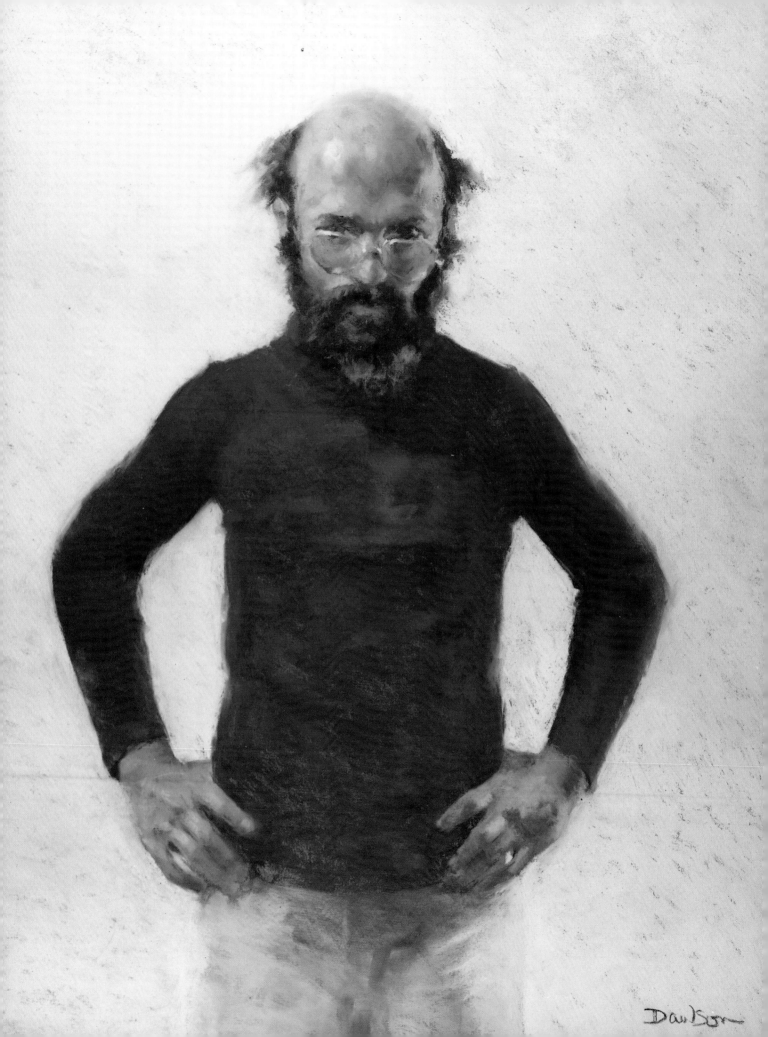

Four Methods of Painting a Background

Every method of painting backgrounds can be understood as a variation on one of four basic approaches: (1) painting a simple, solid-colored background (such as a solid-colored wall); (2) painting an imaginary background (a made-up arrangement of shapes and colors); (3) painting a representational background (what is really there); and (4) painting an abstraction of what is really there (simulating the arrangement of the actual background with nonrepresentational shapes).

The Plain Background

This is perhaps the simplest approach. You pick a color or combination of colors and paint in a solid-colored background. You might ask, Why bother painting a solid-colored background? Why not make it a vignette and leave the background the color of the paper? There are several reasons. First, it allows you to use a color in the background not available in a paper. Second, you can create textures and gradations that are more interesting than plain paper. Last, you can invent a background with little risk to the composition.

To determine if a composition will work well with a solid-colored background, try to visualize the subject as a silhouette. If the composition is interesting as a silhouette, it should be equally interesting against a painted background. In *Taking Her Stand*, the background color is dull so the brightest colors will be in the center of interest. If you aren't certain which color you want, try one or more of the colors you are using in the figure. This ensures color harmony and helps keep your palette simple. If you use a new color in the background, try to use the background color someplace in the figure.

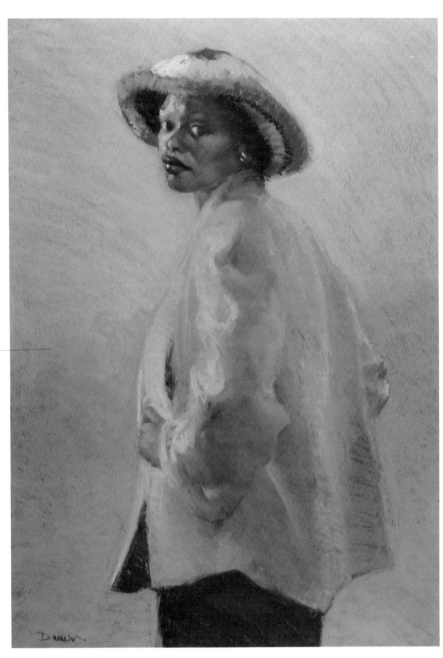

Taking Her Stand
33½" × 23½"
Doug Dawson
Collection of Mr. and Mrs. Leonard Freis

In this painting, the background evolved as the figure evolved. First the background was a light, dull raw umber. This worked but was not every exciting. The color of the light-blue highlights on the back of the jacket was pleasing, but it was inappropriate for the whole background.

The Invented Background

The invented background is one of the most commonly used and least successful methods. When it is done successfully, it is usually done in this way: At the same time that the artist introduces a color in the figure, he uses a bit of it in the background and maintains the distinction between background and figure by using the colors in different proportions. For example, a color that is used sparingly in the figure may be used in greater proportions in the background and vice versa.

The biggest shortcoming to this method is that it depends upon the artist's imagination for the placement of color and shapes. Frankly, the imagination is a very limited thing; it needs the stimulus of the real world, which this method fails to provide. The artist who relies on this method tends to repeat the same arrangement of background shapes over and over again in successive paintings.

Children of the Suriname Rain Forest is an example of an invented background. The children were sitting in front of a wooden shack, but the value and color of the wood in the shack were nearly the same as that of their skin. The composition, as it stood, was weak and colorless, so the artist invented this background. The shapes were based on a landscape the artist had painted earlier. The background was invented, but not out of a void; it came from a real-life experience.

Representational Backgrounds

This approach is great when the background contributes to what you are trying to say in the painting. But often the background has nothing to do with the person you're painting or with what you are trying to communicate. The

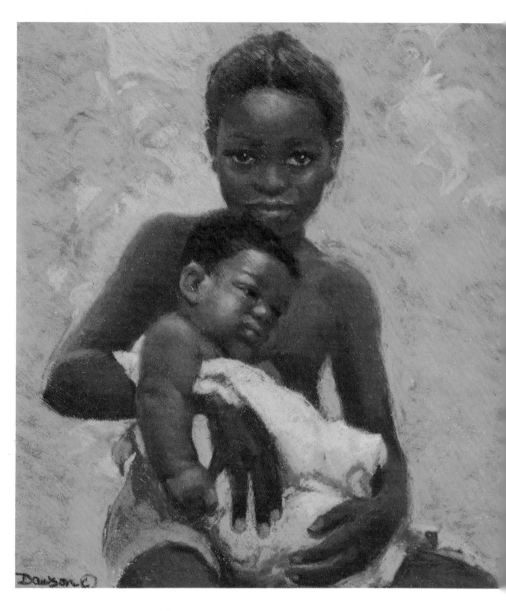

danger for most of us is in the temptation to paint the background simply because it's there—in other words, to paint without thinking.

Spend a lot of time looking for ways to devise meaningful backgrounds. Ask if you can work with the subjects in their homes. This will allow you to explore the use of their rooms, their furniture and their knickknacks as part of the background. When the artist painted *Constance*, he interviewed the subject and her husband. He asked

Children of Suriname Rain Forest
22" × 20"
Doug Dawson

The simplest way to make sure that the green would be under control and wouldn't dominate the figures was to use a warm color underneath. The background was underpainted with a warm burnt sienna that echoed the skin tones. The lightest blue-green in the background is the same cool highlight color used in the flesh.

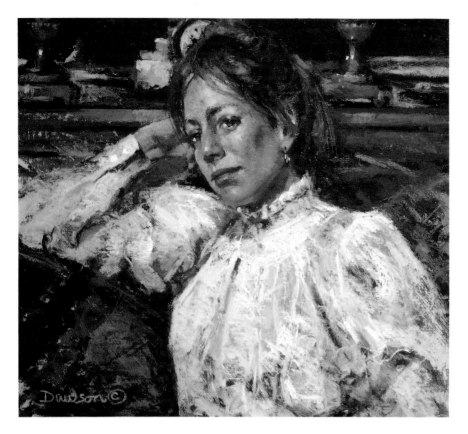

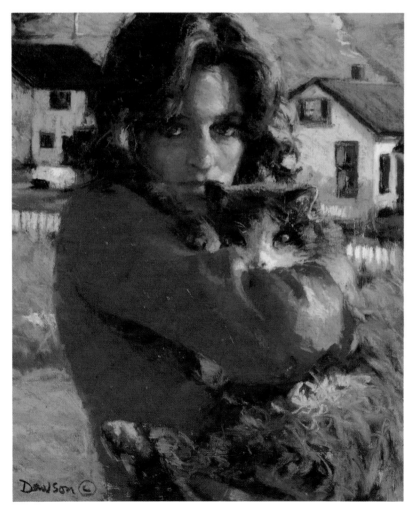

Constance
20" × 22"
Doug Dawson
Collection of Constance Simantob

Constance was painted in her favorite chair in a corner of her favorite room. She had a collection of wonderful antiques, including the candlesticks and clock seen here. Dawson gathered some of the subject's favorite objects and created a composition that has a rich background and relays something of the subject's character.

Sharon
20" × 16"
Doug Dawson
Collection of Marti Foster

Light and shadow on the face give clues to the light and shadow in other parts of the painting. For example, it is often difficult to determine where the break between light and shadow should be in the hair. By looking at the line that separates light and shadow on the forehead, you can often determine where the separation should be in the hair.

them in what part of the house Constance spent the most time, which was her favorite chair, what activity was she most often engaged in: reading, cooking and so on. This allowed Dawson to form a mental picture of who the subject was and of where and how he should paint her. He wanted the background to be part of her.

The painting *Sharon* was done in quite a different way. This was not a commissioned portrait. It wasn't necessary that the background reflect who Sharon was but that it contribute to the feeling of the painting.

In the end, Sharon modeled in front of a brick wall. The background could have been treated like a solid-colored background, but somehow the pose seemed to suggest a story that was only partly told. Dawson set the initial study aside, determined to find a background that would work with Sharon. Eventually he found a landscape setting that suited the model. Using the

Candace
15" × 14"
Doug Dawson
Collection of Dean and Tracy Curry

The background in Candace *is just an arrangement of cloth, painted as shapes and colors. The wrinkles and folds are not painted with the same fidelity used in painting the cloth in her blouse.*

Portrait of Mari
12" × 11"
Doug Dawson
Collection of Dr. Gertrude Hausman

In this head study, the background is an abstraction of the garden and trees in the subject's backyard. The background, no matter how interesting, would occupy just a little space around her face. Dawson chose the garden because the colors worked well with Mari's red hair, and the outside light was gentle on her face.

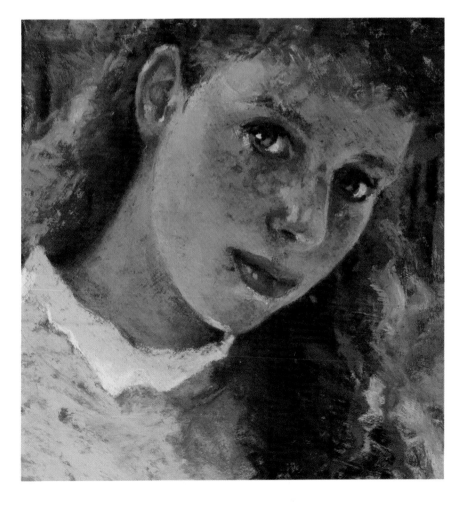

initial study of Sharon and the landscape as reference material, Dawson started a new painting. The background and the model were developed simultaneously.

Abstracting From What Is There

Often the subjects or setting behind the model are of no importance, yet the patterns of color and value may be interesting. A useful approach is to abstract the objects that are there, using their shape, color and value without making any of it recognizable. The background in *Candace* is an abstraction of a created background.

The important difference between abstracting a background and inventing one is that the shapes, colors and values in an abstracted background are not dependent upon your imagination. In *Portrait of Mari*, the relative size and position of some of the shapes in the background were changed. It was

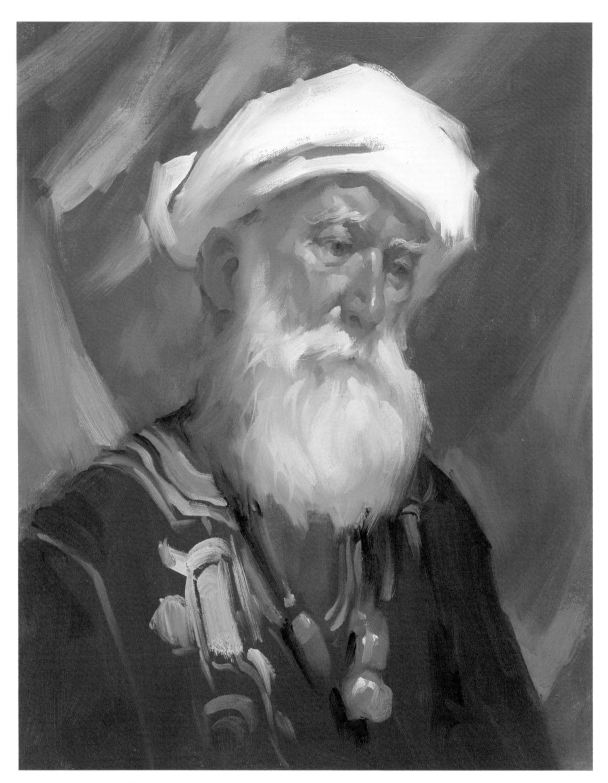

Man in the White Turban
16" × 20"
Ted Smuskiewicz

The background in this painting suggests cloth draped behind the subject. Notice how the same kind of brushstroke is used both on the subject and in the background. However, the edges are generally softer in the background than on the model. This helps to draw our attention to the face and figure.

Basic Portrait Techniques

easy to visualize these changes; they were just variations on what was really there. Ninety percent of the time when you instinctively stop working on a background, your instincts are probably telling you that if you continue you will lose something. If you can identify what it is you are afraid of losing, then you can hold onto it.

Creating an Environment

Sometimes it adds interest to your painting to put your subject in a specific environment. These can be as varied as your subjects. Just make sure the environment relates to your subject and stays in the background, not overpowering your portrait.

Indoors

Details of the family's home, such as interesting windows or furnishings, can add color and pattern to a portrait. Windows make excellent backgrounds in portraits. You can't really know how good they are until you see the portrait framed and hung on the wall. Then you discover that the window in the painting opens up the whole wall and brings a feeling of light and air where none existed before.

Outdoors

The topography of the place or region where we live is meaningful for all of us. The ocean and the beach, with its dunes and blowing grasses, or the mountains, river, lake or forest can all contribute meaning to a portrait. But don't make these elements *too* representational, or the figure will no longer be the dominant motif. It is a matter of concept more than anything else. You must first consciously decide whether the painting is a landscape with a person in it, or a portrait with a landscape in it; then you can proceed.

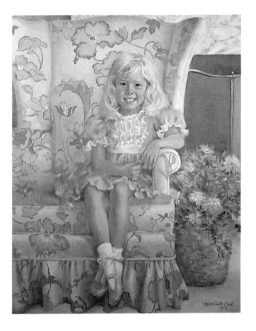

Carrie
32" × 28"
Roberta Carter Clark
Oil on canvas
Collection of Mr. and Mrs. Joseph Hemphill

The artist made several sketches to determine how to trim the chair in this portrait. If she had retained the entire chair, this decorative portrait would have been a painting of a huge chair with a tiny girl in it.

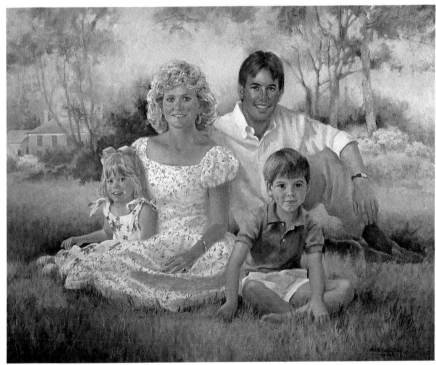

Mary and Jim, Stacy and Matt
42" × 52"
Roberta Carter Clark
Oil on canvas
Collection of Mr. and Mrs. J. W. Warshauer

This family's home, along with the large trees and flowers, was softly rendered to keep the family members the main focus of the painting.

Skies

Using the sky for a background in portraits gives the figure air and space, and sky allows you to compose the colors and cloud shapes any way you like in order to enhance your subject. Cobalt blue, white, and a touch of yellow ochre to warm it up make a good, basic blue-sky mixture. Clouds painted with white and a bit of Naples yellow or a touch of orange look clean and non-threatening.

Try painting a sky in the style of many of the French Impressionists, using small strokes—perhaps ¼" × ½" each—of rose, yellow, blue and lavender tints. Lay your strokes side by side, and do just a minimum of blending. This technique gives a quite distinct feeling of air, much more than any flat color ever could.

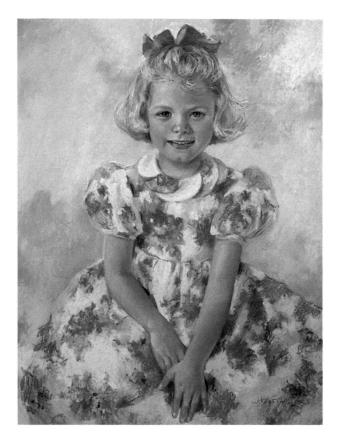

Adele
28" × 24"
Roberta Carter Clark
Pastel on sanded pastel paper
Collection of Mr. and Mrs. Peter Beekman

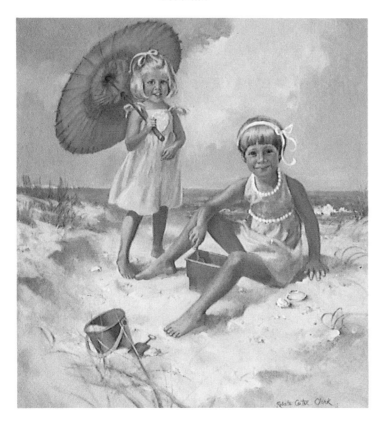

Katharine and Eliza
40" × 38"
Roberta Carter Clark
Oil on canvas
Collection of Mr. and Mrs. Thomas B. Hovey

The midvalue gray used for the sky makes the sand and the figures look bright, as if lit by the sun, and it enhances the strong colors in the clothing and toys; a blue sky would not have done as well. It appears as if a summer squall has just passed through.

Even though the horizon line of the ocean is straight, the design of this portrait is made up of numerous diagonals; diagonal lines always suggest movement, and in this instance, keep the viewer's eye moving around within the painting.

Dark Backgrounds

The Old Masters, John Singer Sargent, Andrew Wyeth and many others, have used dark backgrounds at times. They do add drama. If you want to use dark backgrounds, be sure to vary your edges around the figure—some soft, some hard—so the subject doesn't look cut out and pasted on. (See the portrait of Rawson, below.)

Flowers

Flowers are wonderful in portraits. They give you the opportunity to add almost any color note or shape you need; a boring area in the painting can be made interesting and beautiful. Tiny flowers in the grass can add sparkle to a dull, green area. A flower or two in the hands of your subject can provide those hands with something to do and make them appear graceful. The type of flower you choose along with its container—a crystal vase or a basket—can help convey the mood you are trying to establish in the portrait.

Let's say you are well into the portrait and it looks good. It's the morning of your fourth sitting. The figure looks fine, and the likeness is really there. Before the child arrives to pose, you check the portrait in your mirror. All of a sudden, you see a great blank area in the composition, and your heart sinks. Three days of work on this portrait and you never noticed that place before. What to do? It's time to bring out the flowers. They can really decorate a portrait. If handled properly, they can lighten, brighten and soften an area and still not compete with the head. Time spent working on your flower-painting technique is not wasted. You will be ready to add them when you need them.

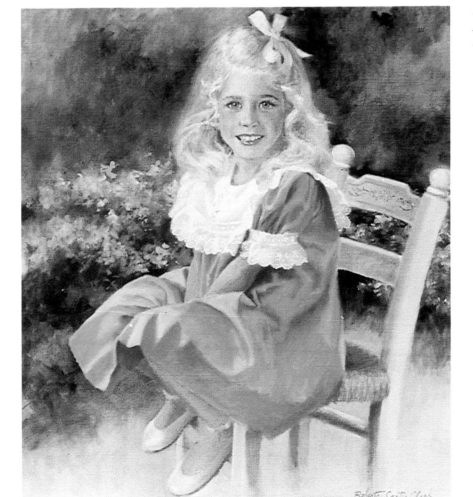

Rawson
38" × 32"
Roberta Carter Clark
Oil on canvas
Collection of Mr. and Mrs. Robert Glover

DEMONSTRATIONS IN CHARCOAL AND PEN AND INK

Demonstration: Charcoal on Tinted Paper

For this exercise, you will need a mid-tone gray charcoal paper. Be sure the paper has some tooth; smooth paper doesn't accept charcoal well. You'll also need (1) two sticks each of medium and soft vine charcoal; (2) charcoal pencil (soft or 6B); (3) kneaded eraser; (4) drawing board (use a wooden or Masonite board 19″ × 25″); (5) tacks, masking tape or clamps (to fasten your paper to the board); (6) easel; (7) old towel or paper towels to wipe your hands; (8) hand mirror; (9) spray fixative; and (10) a kitchen timer. You'll also need a stick of Nupastel for bringing out light areas and highlights.

This will be a portrait in a profile view. Have your model turn her body to one side, but adjust the head so you can just see the other eye; this view is much more interesting to draw than a flat profile. If you're right-handed, it's easier to draw the model facing to her right (your left), and vice-versa. Also, be sure he is facing toward the light, not into the shadow.

Placing the Head on the Paper

Set the timer for twenty-five minutes and have your model pose.

Step back, squint, look through your eyelashes, and study the head, looking from model to paper and back again. Try to visualize the head on the paper. Decide where to place the top of the head, how the head slants, and what size it will be. Then step up to the easel, and with soft charcoal held lightly, make a mark for the top of the head, the bottom of the chin, the outside edges of the face and the back of the head. Try not to draw the head larger than life-size.

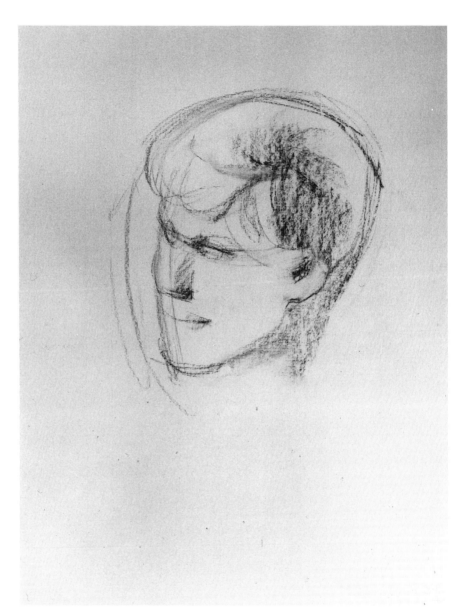

Step 1. *When placing the head in the picture area, be sure that the top of the head isn't too close to the top edge of the paper, that more "air" is given on the side from the face to the margin, and that less air appears at the back of the head. The nose falls slightly above the vertical center of the paper, approximately midway from top to bottom.*

Blocking in the Head

Now that you have the general dimensions, draw the oval shape of the head within them, studying the model. Look carefully to determine the angle of the head. Draw the eye-line halfway down, making it an ellipse, if necessary, to conform to the tilt of the head. *This line is the most important factor in establishing the position of the head.*

Add the brow line parallel to the eye-line. Sketch in the vertical line in the center of the face, and mark the base of the nose halfway between brow line and chin. Add the vertical line at the side of the head, and place the ear just behind it, aligning the top of the ear with the brow line and the bottom with the nose line. Place the mouth line. Indicate the hair mass. Then place the angle of the neck cylinder, front and back, and finally the collar line.

Looking for Large Shapes and Darks

Step back, squint, and look for whatever shape appears most obvious. In this near-profile, it's most likely the hair mass. Now look for shadow areas in the face. First the eye socket, then the underplane of the nose, and possibly a side plane of the nose. Then another side plane at the cheekbone, the side of the face from the temple down to the jaw and chin. Lay these areas in with the side of a small piece of charcoal. Is there dark on the neck? Anywhere else?

Adding Lights; Refining Angles and Proportions

Again step back. You can't define the lights without careful attention to the edge of the face, so hold up your charcoal at arm's length so it appears to lie along the outside edge of the model's forehead. Then walk up and add this line to your drawing. Step back and repeat this process for the line of the angle of the nose, the cheekbone to the lower jaw, and along the jawline to the center of the chin. Lay all these angles in lightly. Check your drawing in the mirror for accuracy. Use your kneaded eraser, but try brushing the incorrect lines off with a paper towel first, or tapping them off with your finger, then blowing away the charcoal dust.

Working Out the Features

Looking at the model, hold your charcoal stick horizontally and sight-check the alignment of the top of the ear with the brow line. Is the top of the ear higher or lower than the eyebrow? Draw the ear, using medium charcoal now for more precise drawing.

Draw the eye shape, the brow, then the bridge of the nose, the hollow at the inner corner of the eye, and the

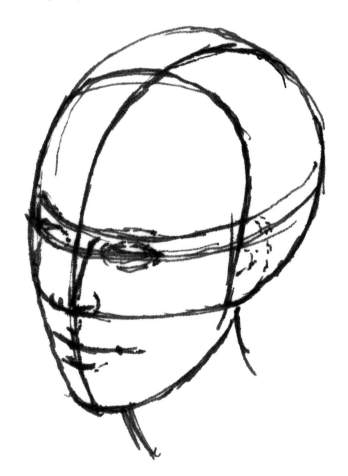

Checking Proportions. *The model's head is in a three-quarter view almost profile, and tilted. This makes the eyeline a downward ellipse, and the central vertical line is way around to her right. The ear line is a quarter of the way around the head to her left side.*

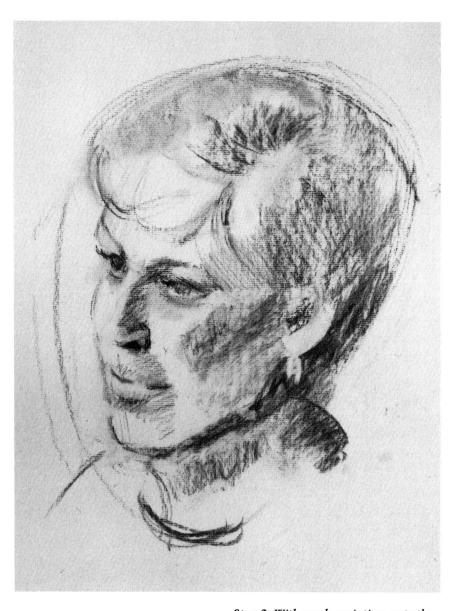

Step 2. *With much squinting, note the direction of the light and lay in the resulting shadow shapes. Now is the time to consider angles of the features. Each feature has its own distinctive shape and direction; still, they must all work together.*

nose. Check, holding the charcoal vertically and at arm's length, how the wing of the nostril lines up with the inner and outer corner of the eye. See how far the mouth and chin project beyond the nearer brow, and sight other vertical alignments such as the corner of the mouth and the eye. Refine the shape of the hair and any collar area.

Putting in the Lights

Now, with the white Nupastel in hand, squint very hard and decide where the lightest areas are—lighter than the halftone gray of the paper. Then *erase* all charcoal from areas where you want the whites *before* you place them.

Adding the Highlights

When we are working on the white paper, the white of the paper serves as highlights. With a tinted paper, light areas are laid in with a gentle touch. Put the highlights in firmly now with the point of the white Nupastel.

Search out the highlights on the model's head—maybe on the forehead, at the bridge of the nose, on the cheekbone, the tip of the nose, and on the lower lip. Add a light in the eye *only* if you see one.

Dark Accents and Reflected Lights

Accents could be in the iris and pupil of the eye, a dot or two in the nostril, the corner of the mouth and in the hair.

Look for reflected light under the chin and lift it out with your kneaded eraser (*no* white pastel here). Add the darks and lights of the collar. Clean up any fingerprints in the background or develop them with shadow. Having a darker background behind the light side of the face throws the head into relief.

This drawing should take one-and-a-half to two hours, or four posing sessions. Put it away so you can look at it tomorrow with a fresh eye; correct it then, if you need to, and spray it with fixative.

Analyzing the Portrait

This portrait of Anne is *linear*. This may be partially because Anne is in a semi-profile pose, which can look quite flat. However, many artists believe it's easier to get a good likeness with a profile. Putting a darker background behind the face sometimes helps throw the head into relief, but a sharp contour line around the face and head may make it look pasted on the background. Varying the weight of your profile contour line, making it lighter where direct light strikes the form and heavier on the shadow underplanes, should help the head to appear more rounded. Softening the edge of the hair shape in at least two places and allowing it to blend into the background also helps.

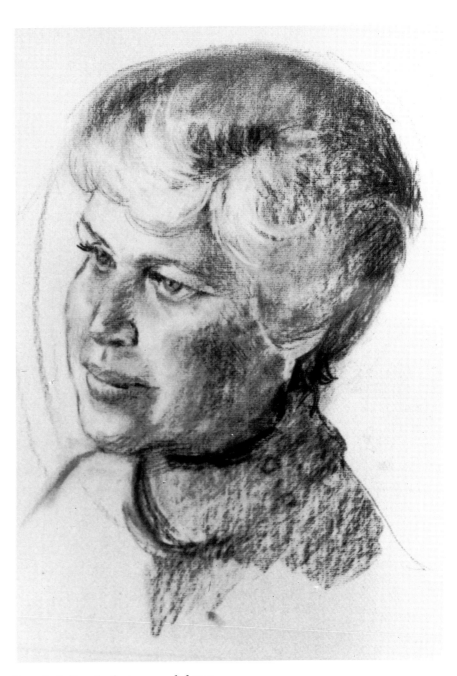

Step 3. *Refine the features and shapes in the head and hair. Darks are added and lights lifted out, but the artist notes that she has lost the likeness—very easy to do when looking at the parts and not the whole. It looks like a round-faced, even chubby, person, not like Anne. Did she move her head a bit? Did the artist change her viewing position? Notice how the right and left eyes differ.*

Finish. *After considerable effort, Anne's character begins to emerge again. The delicacy of her head is a very important part of the likeness. The line defining the far side of the face, a very tricky area in a head turned away this far, was done and redone. After much checking in the mirror, charcoal was lifted out and the highlights put in with white Nupastel. A few dark accents were added in the pupils of the eyes, at the bridge of the nose, in the corners of the mouth, under the chin, and behind the earring. The expression is true now.*

The artist decides the turtleneck is still too heavy. Many artists don't like turtlenecks for portraits. They cover the neck right up to the chin and separate the head from the body. A slightly darker value is placed behind the white hair at left and also at right to make it look as if the tone is behind the head, giving the illusion of a three-dimensional head.

This portrait was completed in two hours and fifteen minutes; it took five posing periods.

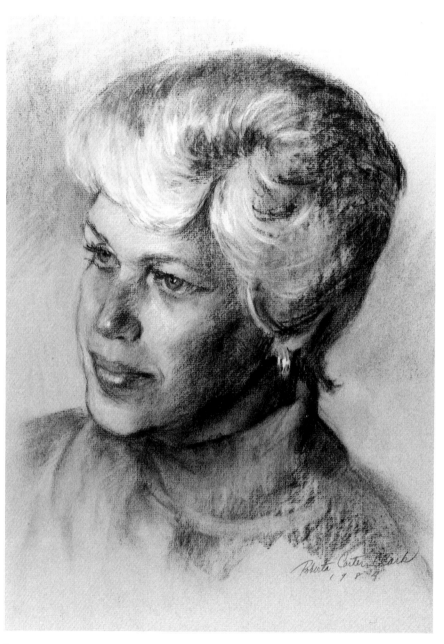

Anne
20″ × 16″
Roberta Carter Clark
Charcoal on gray paper

Detail. *Note how softly the edges are handled; there are no hard lines defining the far side of the face, and there are none around the mouth. The white highlights are kept to a minimum.*

Basic Portrait Techniques

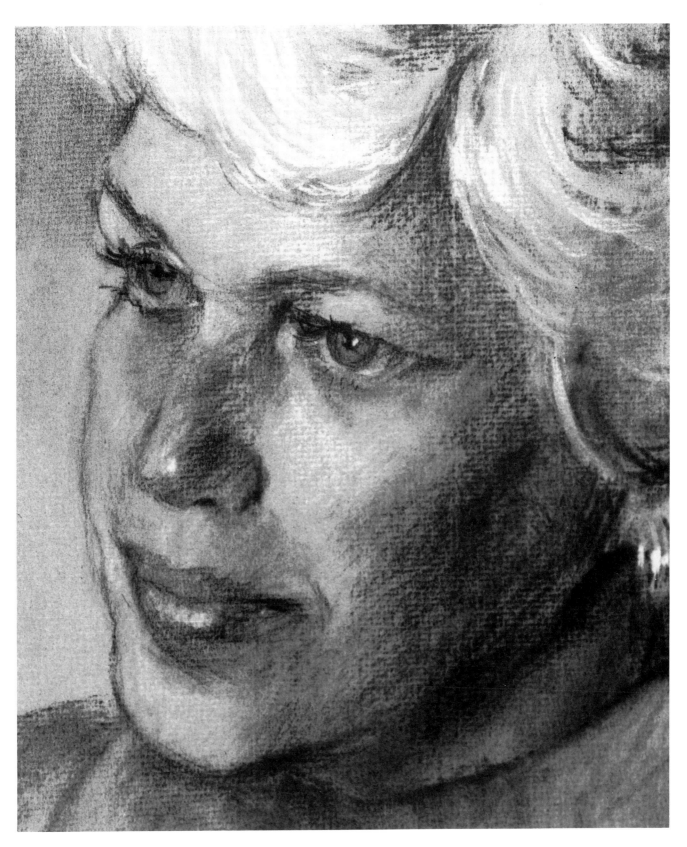

Creating Skin Textures in Pen and Ink

Five of the seven basic ink strokes—or a combination thereof—are useful in the portrayal of human skin: parallel lines, contour lines, crosshatching, scribble lines and stippling. In deciding which stroke to use, consider the mood you wish to establish in your drawing; the size of the portrait; and the age, gender and skin tone of the subject.

The larger the drawing, the more room you have in which to maneuver the pen. Subtle value changes require space and cannot be achieved with any degree of delicacy when the portrait is only an inch high. Dots, parallel lines or the quick-sketch scribble technique work best to suggest the contours of miniature faces.

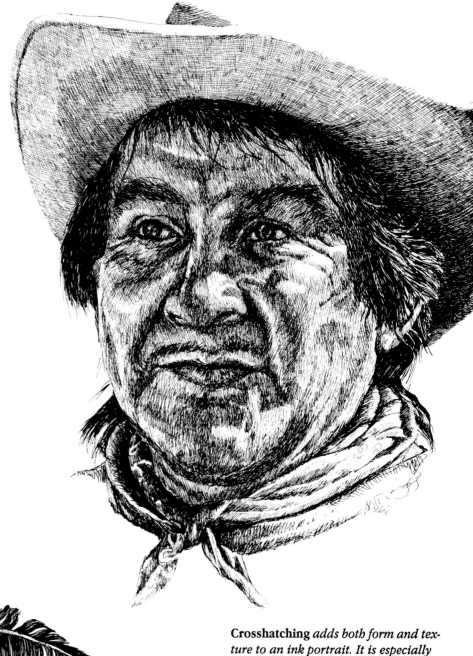

Crosshatching *adds both form and texture to an ink portrait. It is especially good for depicting weathered, aged or dark skins. (Pen sizes 000 and 3×0.)*

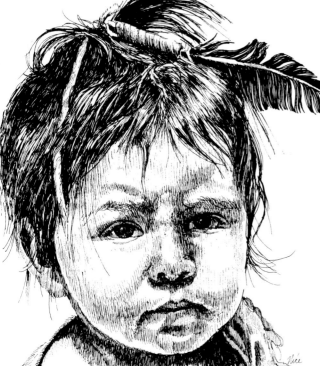

Contour lines *follow the curves of the face with a smoothness that's perfect for sketching children's faces. The girl sketched at left is a child of the Siletz Indian Nation. (Pen sizes 3×0 and 4×0.)*

Basic Portrait Techniques

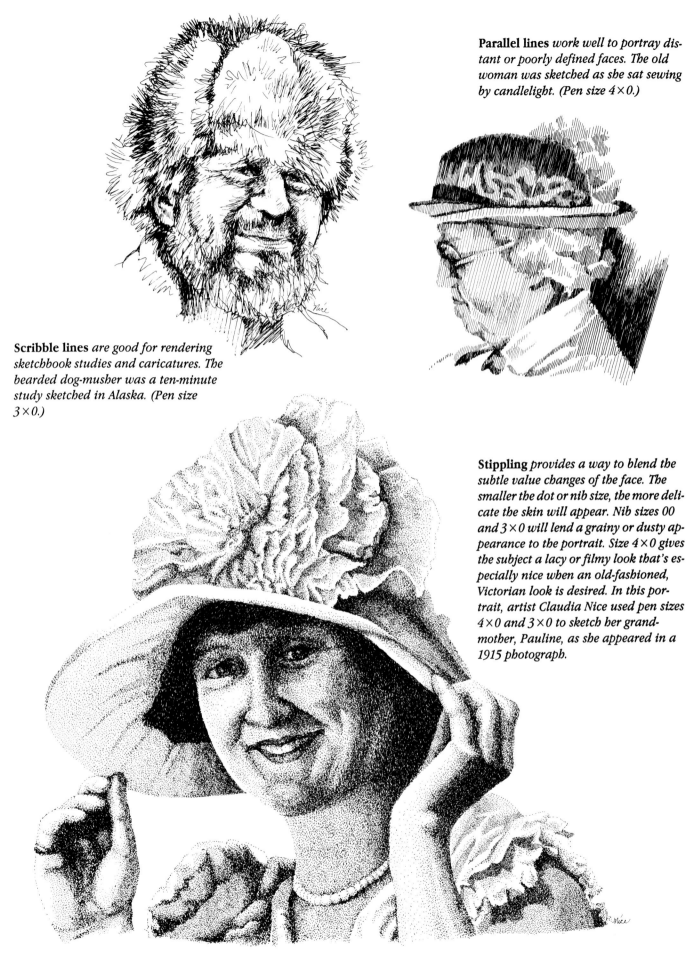

Parallel lines *work well to portray distant or poorly defined faces. The old woman was sketched as she sat sewing by candlelight. (Pen size 4×0.)*

Scribble lines *are good for rendering sketchbook studies and caricatures. The bearded dog-musher was a ten-minute study sketched in Alaska. (Pen size 3×0.)*

Stippling *provides a way to blend the subtle value changes of the face. The smaller the dot or nib size, the more delicate the skin will appear. Nib sizes 00 and 3×0 will lend a grainy or dusty appearance to the portrait. Size 4×0 gives the subject a lacy or filmy look that's especially nice when an old-fashioned, Victorian look is desired. In this portrait, artist Claudia Nice used pen sizes 4×0 and 3×0 to sketch her grandmother, Pauline, as she appeared in a 1915 photograph.*

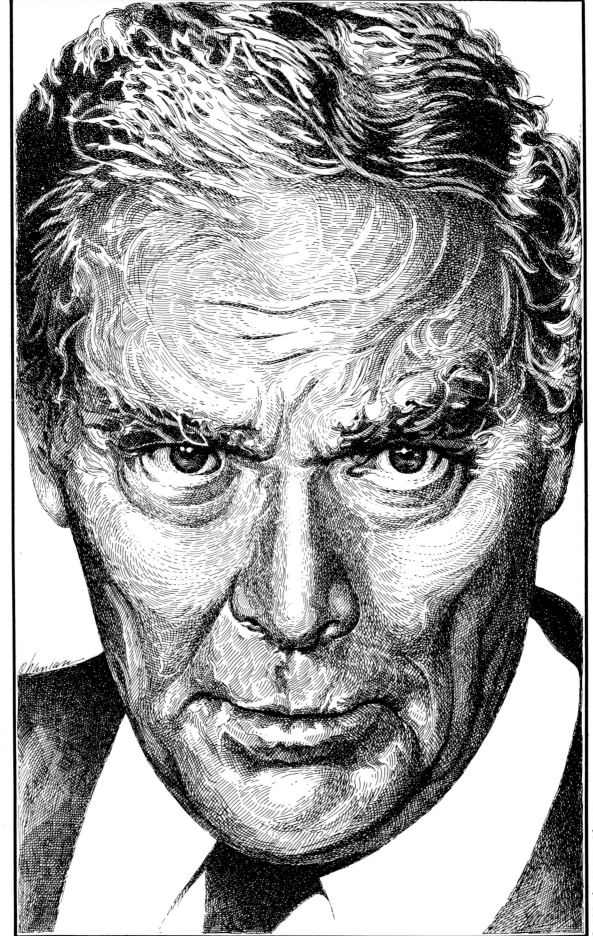

Basic Portrait Techniques

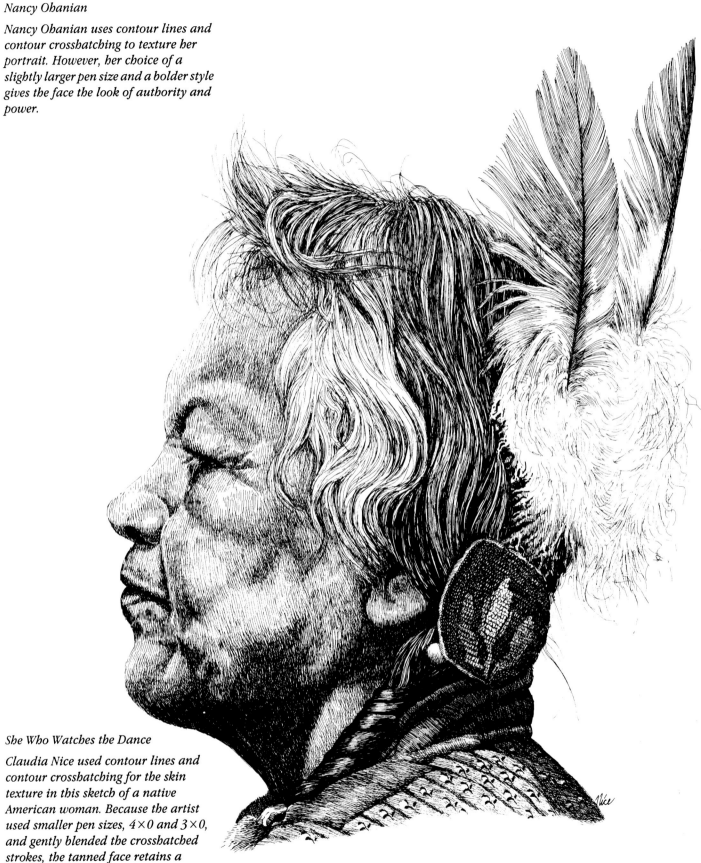

Alexander Haig
10½" × 6½"
Nancy Ohanian

Nancy Ohanian uses contour lines and contour crosshatching to texture her portrait. However, her choice of a slightly larger pen size and a bolder style gives the face the look of authority and power.

She Who Watches the Dance

Claudia Nice used contour lines and contour crosshatching for the skin texture in this sketch of a native American woman. Because the artist used smaller pen sizes, 4×0 and 3×0, and gently blended the crosshatched strokes, the tanned face retains a feminine quality.

DEMONSTRATIONS IN COLORED PENCIL

Demonstration: Portrait of a Young Man

Step 1: Preliminary Sketch. *After several trials and errors, this pose was freely rendered in graphite. Proportions and exact shaping of the forms are established.*

Step 2: Refining Shapes; Delineating Value Areas. *Begin to refine the lines. After a while, the drawing surface may become overloaded with corrections and extra lines.*

Step 3: Transferring the Drawing. *Using a light table, transfer onto a new sheet of paper only those lines to be retained. You may repeat this process several times. Begin to delineate light and shadow areas.*

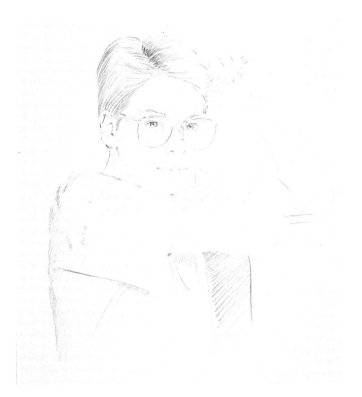

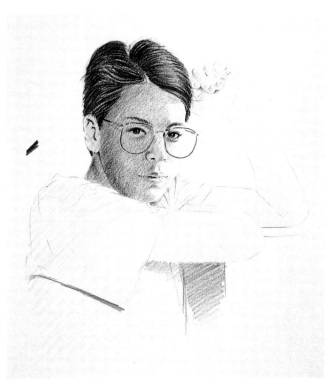

Step 4: Establishing Values. *If you are not sure of the value areas, hold back on transferring the sketch to good paper. Instead, retrace the sketch via the light table and begin establishing tonal values in earnest.*

Step 5: Establishing Values With Color. *Another way of establishing values before beginning the finished drawing is to do a value study in color.*

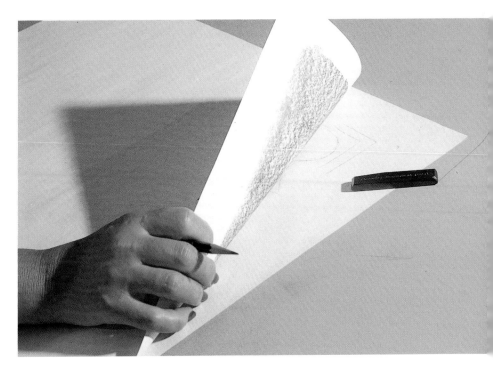

Step 6: Transferring the Finished Sketch. *Once you have all the information needed to proceed with the finished drawing, coat the back of the refined sketch with graphite powder or a soft graphite stick, and place the sketch over a sheet of quality drawing paper or a board. Tracing carefully is the last step in the refinement stage. It's now time to complete the finished drawing.*

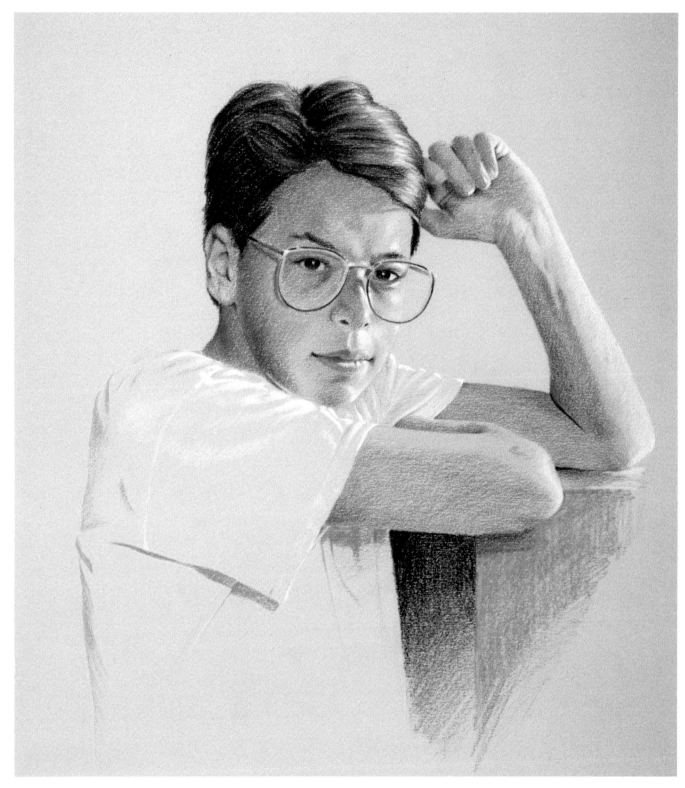

Marco
Bernard Aime Poulin

Finish. *The artist wanted to hold on to the gentler, warmer side of his subject's boyhood, so he softened the intensity of the shadows. Deep and dark, they rendered Marco's aggressive determination. By warming up the shadows and diminishing the value contrasts, Poulin was able to ease up on the tension and focus on the boy's honest and direct look.*

Step 1: Mass. *Establish the main mass framing the face and covering the head. Ignore the flow of hair, the numbers and the thickness.*

Step 2: Smaller Masses. *After establishing the overall shape, squint at the subject. This eliminates details and helps you see the smaller masses that define the directions in which groups of hair flow. Render each dark shape first, comparing each to the others by size, value and form. Apply tonal applications with strokes in the direction the hair falls. Then, delineate middle-tone areas and highlight shapes. Ignore individual hairs completely.*

RENDERING HAIR

Hair can either make or break a portrait. We simply "know" too much about hair—its color, its thickness (or its scarcity!), its properties, and its styling possibilities. And we are intrigued by the sheer number of hairs on our heads.

This academic and cosmetic approach to hair is the reason we fail to render it with ease and give it its fluid, flowing visual qualities. Blond is not! Neither is black, black nor brown, brown. Depending on the light source, hair color will vary dramatically. Under a blue sky, blond hair may have tinges of ochre, olive and ice blue in it.

Black hair under open skies will invariably show highlights of rich sky blue and steel gray. Brown hair ranges from almost black to sandy blond. It is always necessary to study the shades that become integrated with the basic color of a subject's hair.

In colored-pencil drawing, as in any other medium, the artist must abandon his intellectual, logical approach to seeing and focus on rendering what the eyes "say" is there, even if it feels strange at first.

Step 3: Values. *Apply strokes that follow the direction of each small mass of hair. The strokes do not define individual hairs, but concentrate on direction and the play of light and shadow. This step is the most important: It establishes the values that give life to the mass of hair. Once this is done, a tonal layer of local color (blond, brown, etc.) is applied everywhere except highlight areas.*

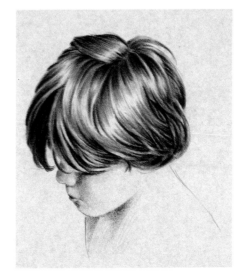

Step 4: Color. *Over the tonal application of local color, each clump of hair is redefined and heightened in dimension through direction-oriented applications of the various colors perceived by the artist's eye. Use heavy-to-light strokes to intensify the darks and midtones. Note whether warm or cool color must be applied. Remember, the ambient or atmospheric light plays an important part in establishing which colors to use.*

Demonstration: Working Over an Abstract Background

The artist's model, Blandie, has an aura of sophisticated innocence about her. The woven background, similar to the rich colors found in traditional batik patterns, was chosen to contrast with her quiet presence. Blandie's personality, blue-black hair and complexion are well suited to strong backgrounds.

The choice of hues for Blandie's coloring counters rules concerning skin tones. Other than local hue, the color of skin depends more on the ambient light than on any other factor.

Step 1. *Purple watercolor was dripped both horizontally and vertically over an almost-dry layer of purple watercolor. The damp paper sponged the edges of the drips and gave the whole field the look of a batik pattern. Once the surface was dry, the preliminary sketch was begun.*

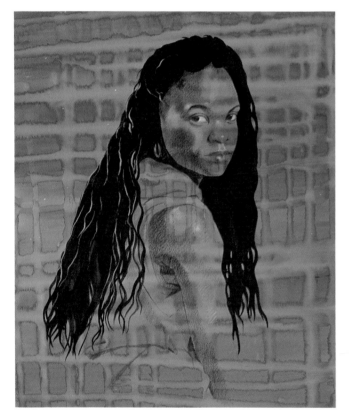

Step 2. *A deep layer of indigo watercolor creates the impact of Blandie's blue-black hair. The next step was to establish the tonal values of Blandie's features with indigo blue. Since the midtone was already established through the background, highlights were added with a white pencil. Ice-blue highlights were used to give her hair its undulating texture. Tuscan red then was overlaid on the indigo shadow areas, eyes and mouth.*

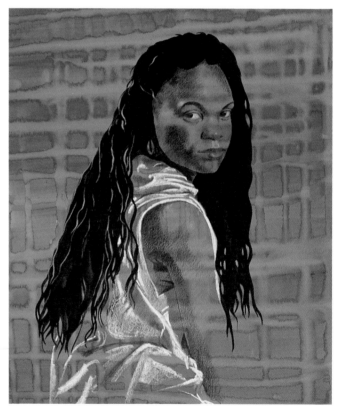

Step 3. *Blandie's forehead, cheek, chin, lips and nose were tinted with vermilion. The girl's sweater then was highlighted to complete the frame around her head. Some golden ochre was layered on the forehead just above the arched eyebrows.*

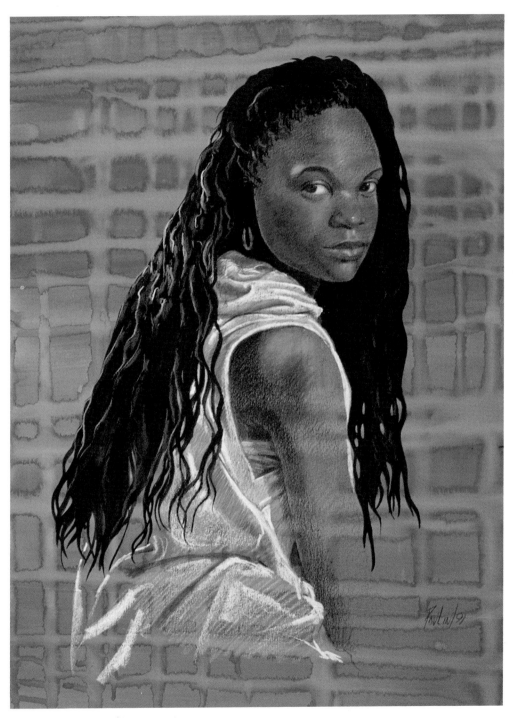

Finish. *To complete the complexion, orange and flesh were blended, adding a golden glow to all the facial features and the arm. A very light, cool gray was applied using curled strokes, indicating medium highlights in the hair. The artist then burnished light flesh and added vermilion accents to the lower lip. Behind Blandie's arm, heavy strokes of slate gray and blue were added to make the sweater recede a bit.*

Blandie
Bernard Aime Poulin

Demonstration: Colored Pencil and Watercolor Combined

Step 1. *The first step involved establishing the tonal values in the hair and facial features. This is called* laying in a grisaille. *James's eyes and hair are very strong features that had to be carefully rendered. James's hair is a ruddy, golden hue and needed to have the highlight areas well indicated. His gray-blue eyes were rendered with light tonal applications of indigo to ensure depth once further colors were added. Then, a watercolor wash of indigo was applied to indicate the sweater.*

Step 2. *An overlay of tuscan red was used to repeat all of the established values. This completed the grisaille. To accent the sweater's texture, the artist added long, medium-pressure strokes of indigo to the light wash on the sleeve. A similar light application of sky blue was added to the darker wash at the back of the sweater. A light layer of terra cotta was then applied to the right side of James's hair.*

Step 3. *Using an ochre pencil, the artist lightly overlaid all of James's hair, including the highlight areas. A vermilion tonal layer was applied to the shadow area of the face and lips. Lemon yellow was applied with heavy pressure to the collar trim. Highlights on the dark sweater and shadows on the turtleneck were added using medium applications of slate gray.*

Finish. *To complete the portrait, the artist emphasized James's hair with the same terra cotta and ochre, leaving the highlights as they were. To deepen the luminous quality of the shadow area, he added a layer of vermilion and an overlay of flesh. Repeated on the shadow side of the nose, this application heightened the intensity of the highlight. Highlights on the glasses and lower lip were lightly burnished with white.*

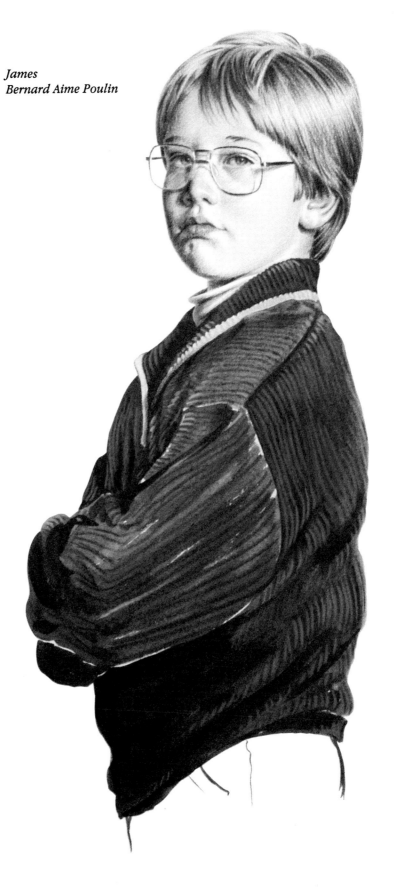

James
Bernard Aime Poulin

DEMONSTRATIONS IN PASTEL

Demonstration: A Four-Year-Old in Pastels

Step 1. *Starting this portrait of Jay from a photograph, the artist sketched in the head and shoulders with a sandalwood color Nupastel stick on sanded pastel paper. Using this same color, she laid in the shadow areas of Jay's face and placed the features. The white of the collar was drawn in with white, soft pastel, and the straps over the shoulders were sketched in.*

Step 2. *Using Grumbacher flesh ochre soft pastel, the artist placed the light areas in the flesh. The hair was sketched in with Nupastel Van Dyke brown in the darks and with flesh ochre in the lights.*

Step 3. *The features are defined with Nupastel sandalwood and Carb-Othello pastel pencil in dark ochre (just about the most useful color in their line for the portrait artist, a middle-value golden brown).*

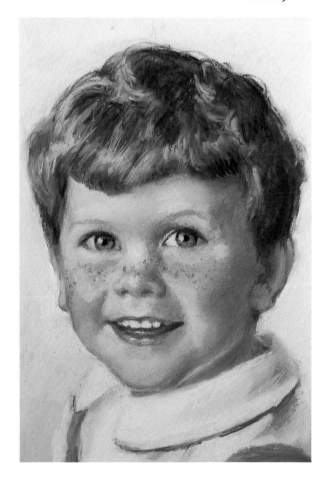

Detail of Jay

Finish. *Jay's mother brought him to the studio for the finish of the portrait. The features were brought more into focus, hitting the highlights and the accents harder. Sanguine Conte crayon touches were added to the eyes, nose and mouth, making them warmer. The teeth and their outline were completed, blending lines to avoid the "kernel-of-corn" look. Using a dark ochre pastel pencil, the artist sprinkled a few freckles on Jay's nose and cheeks. This was done carefully so they wouldn't look like spots. The red trim around the color helped tremendously, and so did the embroidered flowers. More pigment was added to the background and smoothed out a bit. Don't blend the face and hair with anything. You can "kill" a pastel portrait with over-blending in the skin; it takes on a rubbery or plastic look. This head-and-shoulders portrait was finished in three days, half the time of an oil portrait.*

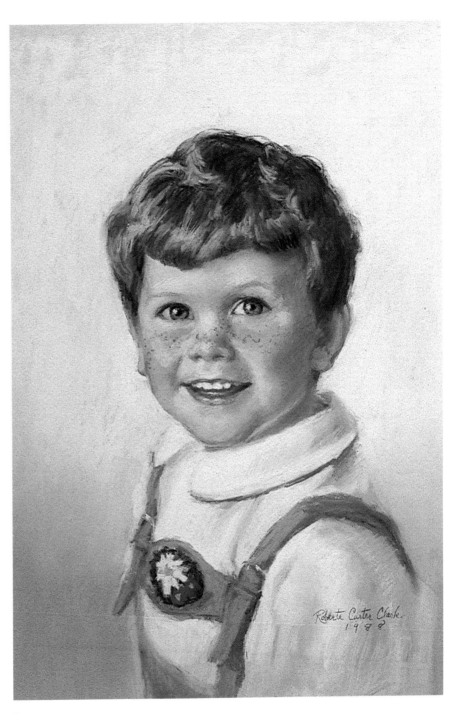

Jay
16" × 12"
Roberta Carter Clark
Pastel on sanded pastel paper
Collection of Mr. and Mrs. Peter Beekman

Demonstration: Color for Emotional Impact

In this demonstration, a bold underpainting establishes both shape and value. Then, with basically three sticks of color, a dark, medium and light, the large shapes of the composition were clarified. The shapes are subdivided with new colors until the smallest shapes or details are reached.

By using a small number of colors for each painting and repeating each color within a piece, you create a repetition that promotes color unity.

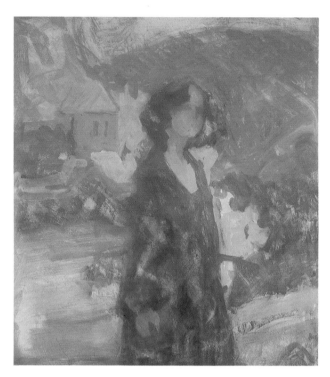

Step 1. *This pastel painting is on ⅛"-Masonite, primed with three layers of acrylic gesso. Big shapes were blocked in with acrylic paint (this affects the color throughout). At this stage, use values that will help you visualize the composition, and use a warm color in the background if cool colors are featured in the finished piece.*

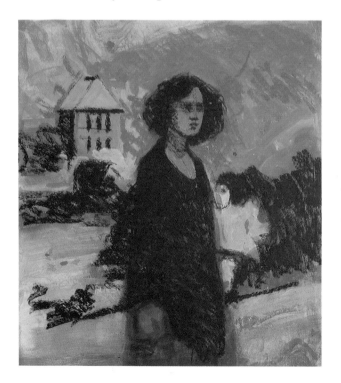

Step 2. *Block in the big shapes and break them down into smaller shapes. In this instance, the shapes painted in acrylic represent the first step in that process. Details like facial features and windows are barely suggested.*

Establishing the background color and value is an important step. We always see colors in relationship to the colors next to them. If the artist completely finished the girl's face, then painted the background, likely as not the new background color would adversely affect the colors used in her face.

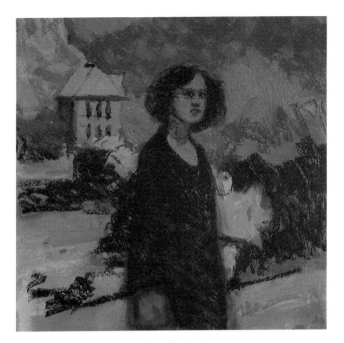

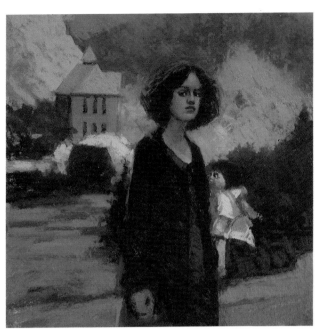

Step 3. *More background is blocked in. At this point, the value relationships between big shapes should be as correct as possible. Introduce the colors that will be used in large areas.*

Step 4. *Generally, it's best to work on all the different parts of the painting at once, but here the artist works with the face. Its expressive character and colors influenced all the colors in the painting.*

Elizabeth's Daughter
37″×33″
Doug Dawson

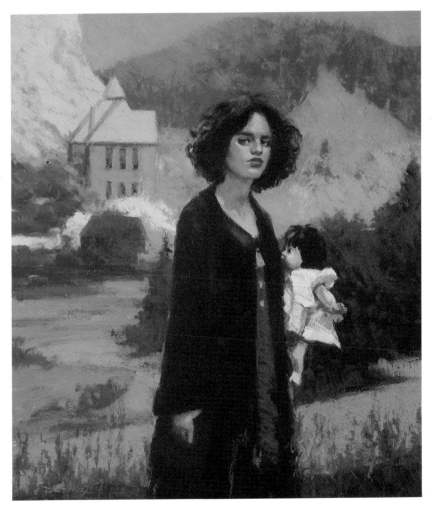

Finish. *In this last stage, all the shapes were broken down into their final sizes, which were determined by Elizabeth's face. All the other shapes are as large as or larger than the smallest shapes in her face. This helps draw your eye to her, making her the center of interest. The effect was almost as if she were all that was in focus in the painting. Points of the pink underpainting show through to help unify the painting.*

Demonstration: Working From Big to Small Shapes

For the initial block-in, select values that are two or three steps apart on the value scale. Limit yourself to three main pastel colors: a dark, a middle and a light value. Block in each large shape with a value that is halfway between the light and shadows of that area, a value that might be called the local tone.

If you are blocking in a very light object, such as a white shirt, block it in using the hue and value of its shadow. Avoid beginning a painting with a very light value pastel, because you will have to work over it, and *working over very light values is a recipe for muddy color.* For other shapes, choose sticks that are halfway between the lights and shadows so you can add color without creating mud.

The three colors selected in the beginning could be representational of what you are seeing, or they could be totally different. The choice depends on what is important in the finished painting. In the painting *Emily,* the subject's blouse was red. The artist blocked it in with blue-green. Too much red might have overpowered the center of interest, which is her face. Using blue-green underneath helps to control the red.

Step 1. *Using three sticks of pastel—a dark, a middle and a light value—block in the whole painting using the biggest shapes possible. In Emily the face was blocked in with burnt sienna, which was darker than the light side of her face and lighter than the shadow side. All skin areas were blocked in using the same color. A small dot was placed on the bottom of her chin to help the artist visualize where the head ends and the neck begins.*

Basic Portrait Techniques

Divide the Big Shapes

The big shapes are the most important ones in the composition. By placing them first, you can visualize how the finished painting will look. After the big shapes are blocked in, divide them into large, simple, shadow shapes (dark) and large, simple, light shapes. Do this either by blocking in the shape of the shadow over the large shape, as in the painting of Emily, or by blocking in the shape of the light. Both methods will divide the large shape into light and shadow. These large shapes are then divided into smaller, intermediate shapes.

When you add a new shape, look for other places in the painting where that same color or colors can be used. This helps keep your palette simple. There is a great temptation to use a different stick of color for each new shape. Resist that temptation or you will have too many colors, and the painting will be out of control.

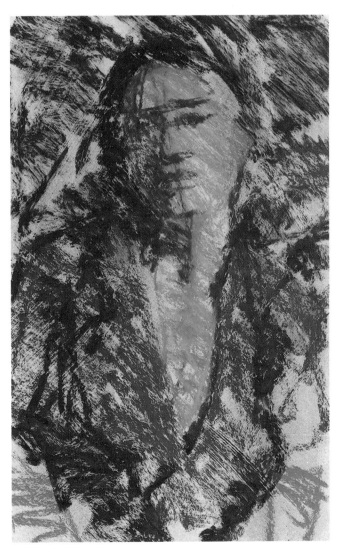

Step 2. *Large, simple shapes denoting shadow areas divide the foundational shapes.*

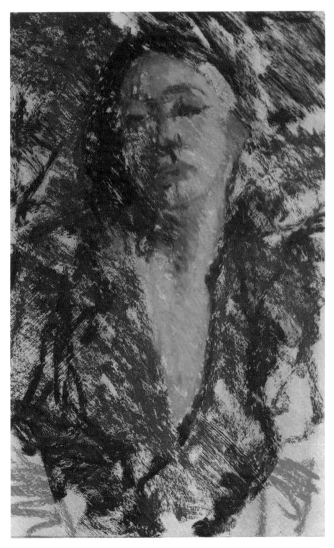

Step 3. *Intermediate shapes were blocked in. One color of red blocks in the shapes of the ear, upper eyelid, lips (treated as one shape), chin, edge of the jaw, the forehead and the cheek. The shadow side of the face is divided, and the shadow under Emily's nose and eyebrows is redefined. The light over her eyelid on the shadow side is noted.*

Keep the Division of Light and Shadow

At this stage, as new colors are introduced, you risk losing the value relationships between the light side of the face and the shadow side. This happens because the artist, without thinking, uses colors in the dark shapes that were intended for the light shapes, and vice versa. Try to avoid carrying the light sticks into the darks and the dark sticks into the lights. If you see a dark color in the shadows that looks like the same hue as a color you used in the lights, look for a darker shade of that color.

If you lose the big light/shadow relationships between shapes, correct the problem by backing up to an earlier stage and loosely reblocking the large, lost shapes. In the painting *Emily*, that would mean going back to step two. *Don't try to solve this problem by painting details*.

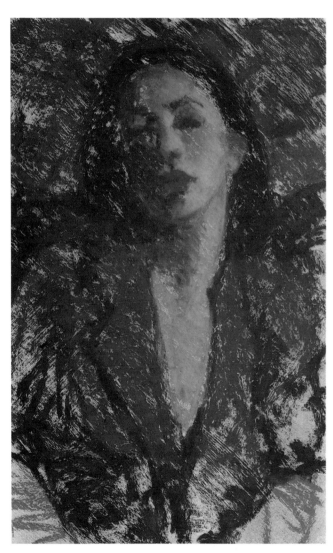

Step 4. *Divide the background into smaller shapes using colors planned for the finished painting. Continue dividing large shapes into intermediate shapes. In Emily, the light shapes of the blouse were blocked in with violet-red. This same color was added to the mouth. Proportions should be checked at the beginning of a painting, at this stage, and at the halfway point.*

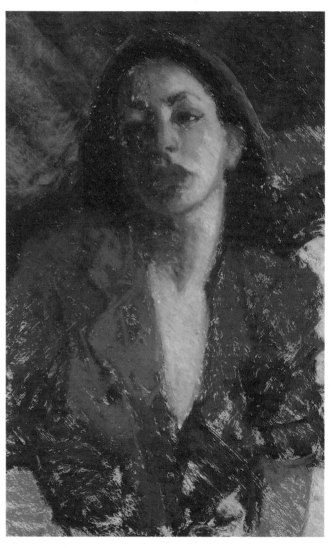

Step 5. *At this point, continue to work on the shadow side of the face, keeping the shapes intermediate-sized to give an impressionistic feel to the painting. Place the lighter values in the painting.*

Block in the Background

Don't forget that blocking in the background early is an important step. Don't put off painting the background. Colors are judged in relationship to the colors that are next to them. The colors used in Emily's face will be judged in relationship to the color around her face, i.e., that of her hair, of the background, and to a lesser degree, of her blouse. With the background in, the artist can make good color decisions about her face and other parts of the painting.

Decide How to Finish

If the shapes are left large or intermediate in size, the painting will be impressionistic in style. If they are very small, it will be realistic. *Emily* has an impressionistic feel.

In this last stage, make sure each shape is the color and value you want it to be. Correct the edges between shapes, making some edges soft where they should be soft and keeping others hard where they should be hard. Eliminate the spots of board showing through, especially in the dark areas of the painting.

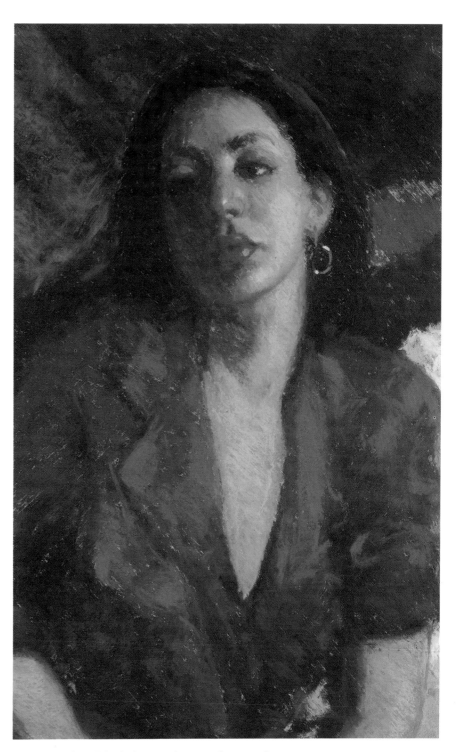

Finish. *Hold off the lightest values until the end of the painting process so you can place them cleanly and precisely.*

Emily
22" × 14"
Doug Dawson
Pastel

DEMONSTRATIONS IN WATERCOLOR

Demonstration: Portrait From a Live Model

Preliminary Sketch

Step 1. *The photo on page 33 shows Pat in the pose the artist liked best. Begin by using simple geometric forms to establish the general position and the swing of the body.*

Step 2. *On a clean sheet of tracing paper overlaying the first, delineate the features. These lines are very generalized at first, and then refined with more overlays. Here you see overlay number three.*

Step 3. *Full attention to finding the planes and shadow areas on her face comes next. This is all the information that's really needed, but you may further refine your sketch.*

Step 4. *In this final refinement, Pat's teeth and earring were located. Should any unforeseen problems arise, Pat's smiling face is still there for the artist to see.*

Applying Color

Before we begin to paint, let's have another word about brushes. Use brushes that are appropriate to the size of the area to be painted. You wouldn't paint the side of a house with a watercolor brush; it's important to use a brush large enough for the area to be covered. When painting a face, try a no. 10 round brush for the skin tones and hair (portrait heads are usually 6″-8″ high). As you work into smaller areas, switch to a smaller brush. Most of the detail is done with a no. 6. For very small crevices around the mouth or in the eyes, choose a no. 3. For background areas, a 1-inch Aquarelle is good. Be careful not to select a brush that's too small. The use of a small brush can result in a "picked over," fussy look.

It's important to remember to clean your brush before you add each new color. Use two brushes, especially if you're working two colors and want them to mix on the paper. You can work fast into a wet area with the assurance that the colors are not being neutralized on the palette.

Step 1. *The skin color is a mixture of cadmium red and new gamboge. When dry, the value is almost 2. After her face, neck and wrists were painted, her shirt was given a light wash of rose madder alizarin. Any other rosy hue, such as a light value of alizarin crimson or Winsor red, would serve as well. (Stay away from rose madder genuine. That pigment has a way of lifting with the addition of subsequent washes.)*

While these colors dry, wet the area behind her hair with clear water and drop in brushloads of the skin color and then that of the blouse. Let the entire painting dry before proceeding with the next step.

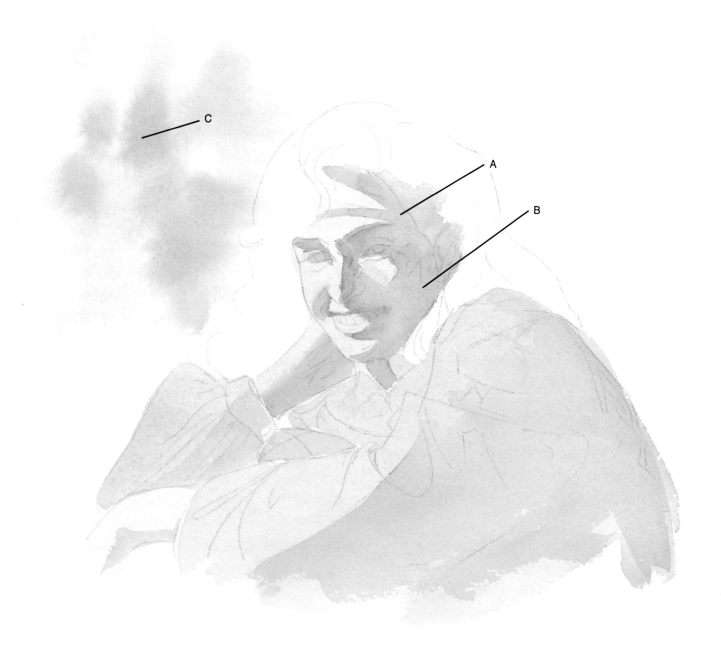

Step 2. *Mix one puddle of sap green and new gamboge, and another of burnt sienna and alizarin crimson, checking to be sure each of these mixtures is close to value 6 (when dry).*

Beginning at Pat's hairline, draw the alizarin mixture across her forehead into the temple. Then, quickly switch to the other brush, which is loaded with yellow-green. Bring that color into her left eye (A). Returning to the first brush, continue the warm color down into her cheek. Next, run a line of cadmium orange along her jaw, letting the color

combine with the red mixture to suggest reflected light (B). After the entire shadow side is complete, use a brush moistened in clear water to soften the edges wherever needed. If the edges are too dry to correct in this way, it's best to wait until the painting is near completion and make such corrections with a bristle brush.

Cadmium orange is very opaque, and since it should blend smoothly with the red mixture, use enough water to permit the heavy pigment to flow freely.

Paint the shadow side of Pat's wrists,

using a fairly wet brushstroke of new gamboge along the bottom, and immediately add the alizarin mixture, softening the edge as the shadow approaches the light.

Now the background gets another coat. Once again moistening the entire area with clear water, use just the tip of the brush to drop color into the wet area (C). The soft-edged dots of color are intended to suggest leaves later in the finished painting. Everything must dry before the next step.

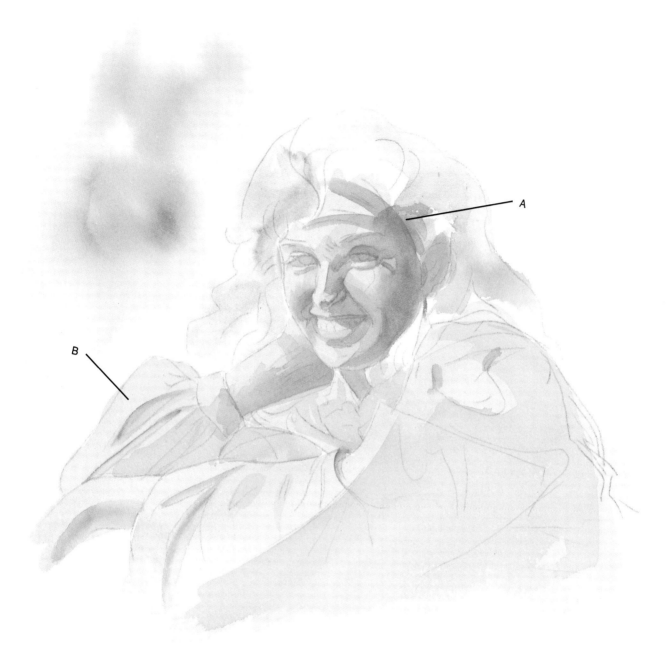

Step 3. *Since there is very little modeling to be done on the sunny side, begin shaping both sides at one time. On a clean palette, mix a middle-value purple (alizarin crimson and ultramarine blue) to darken her temple, upper eyelids, and the corners of her eyes. This same color serves to accent the shadow from her eyelashes that falls across her cheek and then continues into her hairline (A). The modeling on the sunny side is accom-plished with a mixture of cadmium red and new gamboge.*

Notice the folds in her shirt sleeves. Moisten the area and add new gamboge to suggest reflected light, then immedi-ately run a fairly thick line of rose mad-der alizarin along one edge (B). The shadow will be completed in the next step. Moisten the entire background one more time with clear water and add more color.

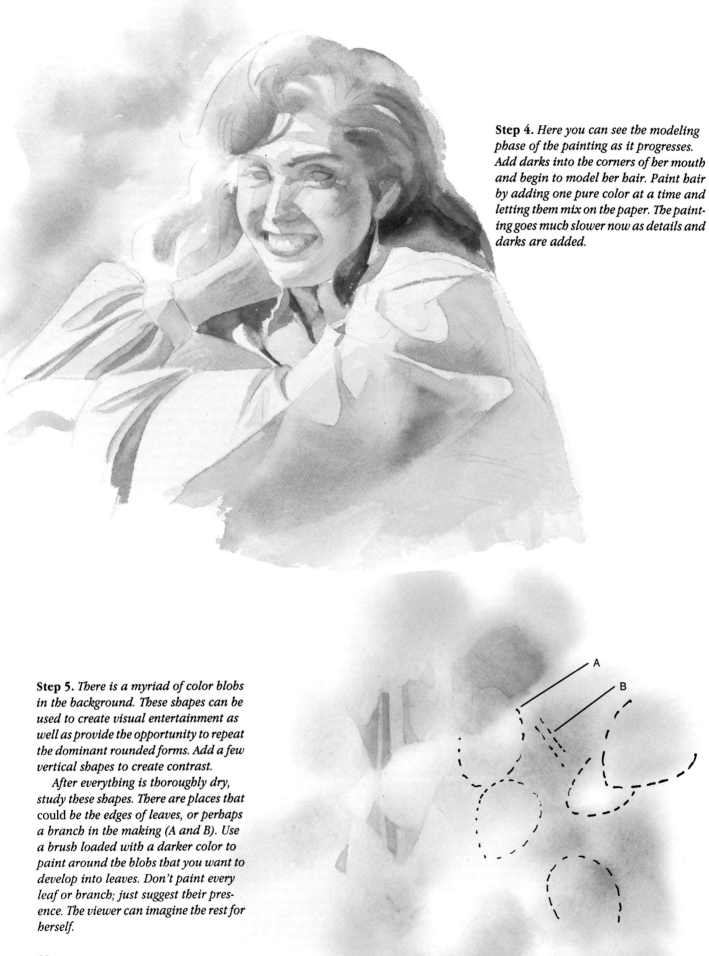

Step 4. *Here you can see the modeling phase of the painting as it progresses. Add darks into the corners of her mouth and begin to model her hair. Paint hair by adding one pure color at a time and letting them mix on the paper. The painting goes much slower now as details and darks are added.*

A

B

Step 5. *There is a myriad of color blobs in the background. These shapes can be used to create visual entertainment as well as provide the opportunity to repeat the dominant rounded forms. Add a few vertical shapes to create contrast.*

After everything is thoroughly dry, study these shapes. There are places that could be the edges of leaves, or perhaps a branch in the making (A and B). Use a brush loaded with a darker color to paint around the blobs that you want to develop into leaves. Don't paint every leaf or branch; just suggest their presence. The viewer can imagine the rest for herself.

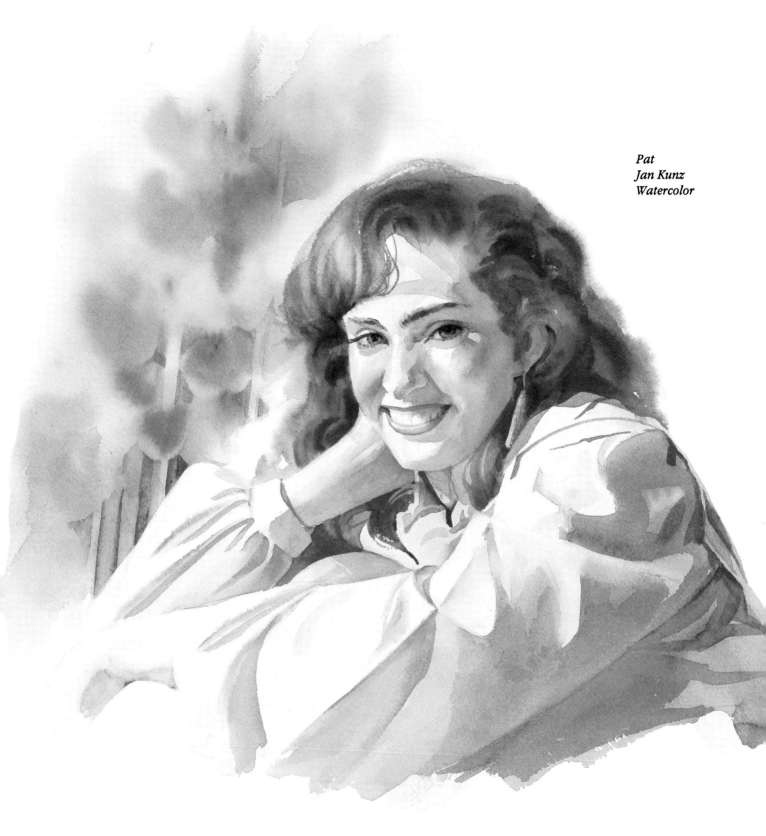

*Pat
Jan Kunz
Watercolor*

Finish. *Painting the background is fun, but now this area seems to demand too much attention. To correct this problem, glaze over the entire background with a light wash of cobalt blue, avoiding Pat's hair and being careful to keep the edges soft. Whenever you use cobalt blue in washes, it's a good idea to use fresh pig-*

ment. When cobalt blue becomes dry in the palette, it has a tendency to break up into hard little chunks. The last thing we need here is an unexplained streak of blue across the background.

The shadow side of the sleeve is painted last. Use a warm, reflected light on the bottom edges. It appears quite

green in the photograph, but green would appear cool and neutralize the rosy color of the blouse. Yellow, on the other hand, adds glow and is in keeping with the mood of the painting.

Here is Pat's portrait. Her smile and the harmonious colors and shapes all say, "Warm, approachable, friendly."

Demonstration: Portrait From a Photograph

This portrait was done from the photograph on page 29. Even though the photo had minimal contrast, we emphasized the value change in the shadow shape.

Step 1.

1. First, mix new gamboge and alizarin crimson and paint the entire face, including teeth and eyeballs. Even though you want the eyes and teeth to appear white, they are usually in shadow and are almost never white. To paint around them is to ask for trouble.

2. Carry the color into the hairline and down the neck. Try to keep the value of this wash light (about 2). After everything is thoroughly dry, determine the value of the skin color.

3. Mix a somewhat rosy puddle of burnt sienna and alizarin crimson on your palette. Check to see that when the mixture is dry, the value is 40 percent darker than the initial skin color. Be ready to add a light touch of ultramarine blue to the alizarin mixture (making a blue-violet) for the cooler areas around the eyes and forehead. Now mix another puddle of yellow-green (sap green plus new gamboge).

4. Start on the left side with the violet color and paint the shadow over the eye. Wash out the brush and pull the color over the nose into the other eye. Float some of the green mixture into the temples. Don't worry if it floods back into the eye. Pull that color out into the forehead and down the cheek. Add the alizarin-crimson-and-burnt-sienna mixture while it is still wet, and continue spreading the color down under the chin. Add cobalt blue at the bottom of the chin to suggest reflected blue from the shirt.

5. Carefully paint the tip of the nose and right into the cast shadow with the alizarin mixture. Immediately add a drop of new gamboge into the wet pigments at the nostrils. Soften the top edge.

6. While all this is drying, paint a base coat on the shirt with ultramarine blue, adding a touch of yellow in front for sunlight.

Basic Portrait Techniques

Step 2.

1. Now model the areas of the face that are in shadow. The light implications of the planes of the head and face on your drawing are useful in this step. First do his right eye. Use a light wash of alizarin crimson and ultramarine blue, and paint the shadow under the lid. Then use the same color on his left cheek and pull it into the shadow along the chin. Model the left side of the nose. Now paint one cheek at a time by first moistening the area and using a wet brush and a bit of cadmium red on the tip. Let it dry to a soft edge.

2. Paint the upper lip and bring some of the color down to define the gum line. Avoid making a dark line around or under the teeth. Use the same color to paint the bottom of the cheek. Using a dark value of alizarin, burnt sienna and ultramarine, model under the eye, the cast shadow under the lip and the detailing in the ear.

3. Finally, suggest the fold in the shirt by adding a darker value of the blue.

Step 3.

1. Start with the hair. First, wet the top of the head. The top of the head has to be cool because it is reflecting the blue of the sky. Use Winsor blue, Payne's gray, and a touch of burnt sienna. Add green for the area toward the sunlight. The brushstrokes for the hair should follow the general direction of hair growth. Paint with a wet-in-wet technique. Keep the edge along the face soft.

2. Add a dark (alizarin crimson and burnt umber) in the corners of the mouth. Use a clean, wet brush to pull the two sides together, making the sides darker than the middle. Use the same colors and darken the inside of the nostrils.

3. To do the eyebrows, first moisten the area, then use a very dark mix of Payne's gray and blue to add color to the darkest place, and let it spread.

4. For the eyeball, darken the iris and pull a little dark around the edge of the lids.

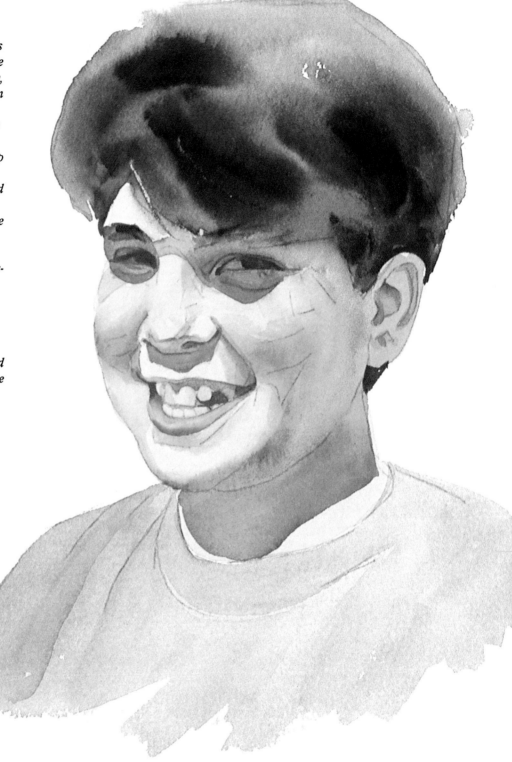

Basic Portrait Techniques

Finish.

1. Make sure your paper is bone dry, and erase the pencil lines. Soften the edges of the eyes by taking an oil brush and clean water and scrubbing the edges lightly.

2. Use a warm dark to darken the ear shadows and the crevices around the collar. If it seems to need it, glaze some violet to darken the neck under the chin.

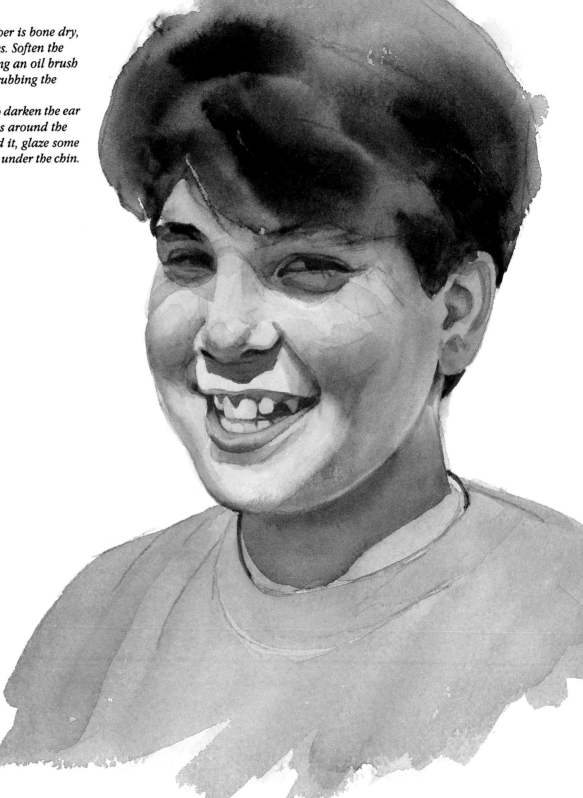

*Jonathan
Jan Kunz
Watercolor*

DEMONSTRATIONS IN OIL

Demonstration: Using a Line-and-Mass Approach

For this portrait demonstration, the artist worked from a live model. The first big lines were sketched with a thinned mixture of terra rosa and viridian on a 20″ × 24″ stretched canvas with a white ground. This gave the important basic proportions and their placement. Next, the locations of the head, neck, shoulders and arms were indicated followed by the darker masses. There's no detail at this point, but the dark shapes use correct edges. A little tone was worked in around the head and on the shirt for contrast. Some incorrect edges were wiped out and the correct ones put in. At this beginning stage of the painting, it is important not to get involved with too much detail. Put all your efforts into establishing a good drawing that shows basic proportions and the major masses of tone.

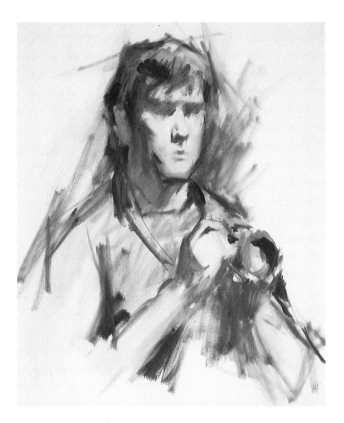

Step 1. *Using viridian and terra rosa without any white, major dark tonal areas are sketched in detail. The hands are blocked in according to their basic planes or surfaces. At this stage, line and tone serve as a foundation on which to build the basic colors.*

Step 2. *This first tonal drawing of the facial features uses simple, dark shapes. The edges of these dark masses have to be accurate to show the underlying form. A solid background color was put in; its final appearance in the painting had already been planned.*

Step 3. *Block in some of the basic colors. Using families of color as a guide, first find the correct hue and tonal values, such as a dark yellow-green for the background. Next, determine the color's intensity and grayness by adding other colors. Before getting into the lighter areas, make sure the darks and middle-value colors are put in for contrast.*

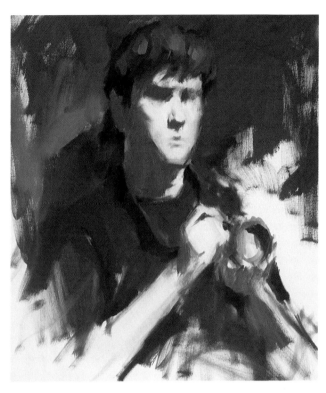

Step 4. *Add color to the head, keeping in mind the surface form and basic proportions of the drawing. Continue to avoid detail in the facial features, but start modeling in the major planes of the face using warmer and cooler colors. Terra rosa, cadmium yellow light and a little alizarin were the basic pigment colors used for the fleshtones. White was added to lighten values, and viridian or cobalt blue was used to cool and gray colors.*

Step 5. *Block in the color of the hands using warmer and cooler colors. Darker values began to bring out the basic surface planes of the form. The dark shirt served as a good contrast for the lighter fleshtones.*

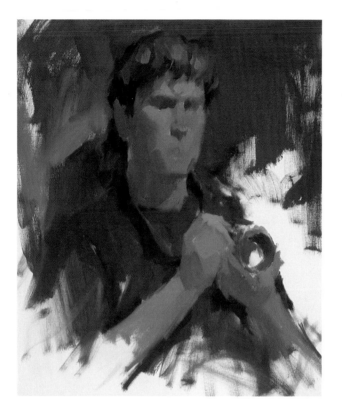

Step 6. *As the block-in colors filled up the picture, a solid feeling of form and a sense of light started to appear. Detail is still lacking, but much of the basic form is indicated.*

Detail. *Refinement in the facial features is starting to take place. The eye socket was shaped more solidly by correcting edges. The nose and mouth have begun to emerge now because of more subtle modeling with value and color. Highlights helped to complete some of the facial forms. A few more lights and darks brought out the hair.*

Always model form according to the main light illuminating the subject.

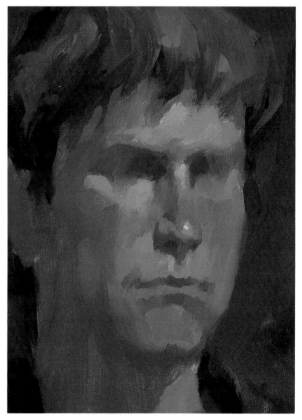

Detail. *Always build modeling and detail in the hands after you have a good indication of basic surface planes. More refinement with value and color was also put into the camera by observing its basic shape.*

Finish. *In this final stage of the painting, the background was finished with some warmer colors. The background was painted against the figure's form to correct its outer edge where necessary. Finished form was brought out in the facial features as well as the hands by refining colors and edges. All this begins to pull the painting together and gives it a finished appearance.*

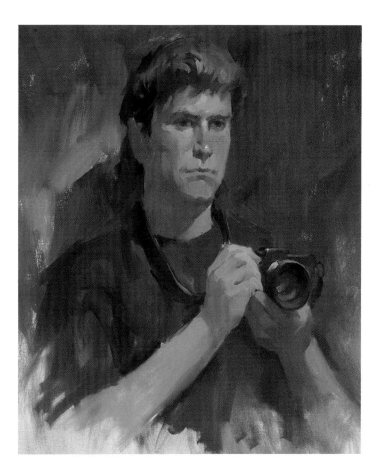

Naldo
20" × 24"
Oil on canvas

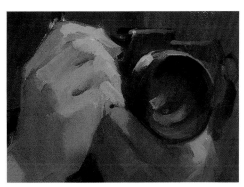

Detail. *The fingers were finished in both hands by controlled modeling with value, color and edges. The original block-in of the basic surface planes was a foundation for this detail.*

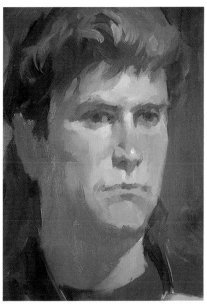

Detail. *The eyes were painted directly into the dark shapes of the eye sockets using the correct dark and light accents and edges. A little more modeling was done in the face and head using subtle changes in value and color temperature. All contour or outer edges were corrected by painting into the background or by painting the background into the figure's form. A few sharp accents were put into the hair for interest and form.*

Demonstration: Depicting Sunlight

This demonstration was painted from a photograph chosen because it had so much life in it. It made a wonderful portrait of four-year-old Grace in her Easter hat.

Step 1. *The stretched canvas was coated with a raw sienna imprimatura, and the figure was drawn with a no. 6 filbert bristle brush and more raw sienna. The light was wiped out on Grace's left cheek with a paper towel. A dark mixed from burnt sienna and ultramarine blue was scrubbed onto the hair, cobalt blue on the dress, and sap green for the background.*

Step 2. *Titanium white was added to the hat and the light area on the collar, and a mix of white and cerulean blue was added to the shadow area of the hat and collar, allowing some raw sienna to glow through. The features were redrawn with raw sienna and burnt umber. A few fleshtones of white, raw sienna and scarlet lake were painted on the face; the artist carefully avoided getting the skin too pink. The face was toned down with light blues.*

Grace visited the artist after this step, and Clark found the skin tones she'd painted to be too cool, too grayed.

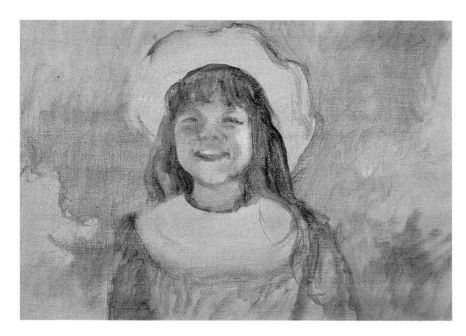

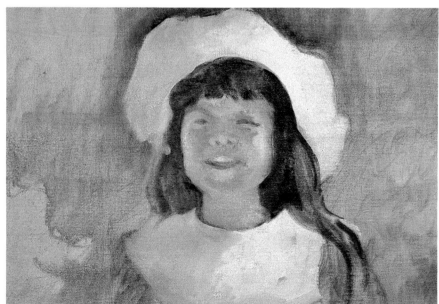

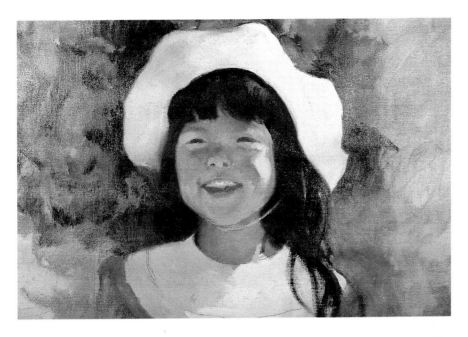

Step 3. *After seeing Grace, the artist felt she could take some risks with the skin color because most of the face in the photo was lighted with reflected light. Titanium white, raw sienna and cadmium orange were added, plus a little scarlet lake on the cheeks. To make the hat look very white, the background was darkened with sap green, ultramarine blue and burnt umber—and* no white. *Brushstrokes were kept rough and uneven so some of the raw sienna imprimatura would peek through and contribute to the feeling of sun breaking through dense foliage.*

Grace's hair was made as dark as possible with ivory black, alizarin crimson and ultramarine blue; also, a mixture of white and cobalt blue were added to the shadowed area of the collar. The bright lights on her face were painted with titanium white with a touch of orange to warm it. You can't paint sunshine with cool whites.

Finish. *After the shape of the hat had been refined, the small openings in the hat brim, so necessary for allowing the sunlit spots on Grace's hair and face, were painted. Some orange-and-white reflections of the fleshtones were worked into the cool shadows on the collar. Clark had to wait until the white collar dried before painting the strands of hair over it. The finished portrait has Grace's sparkle.*

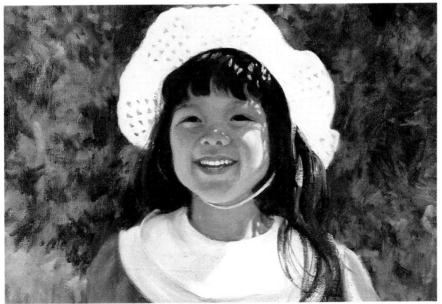

Grace, age 4, in Her Easter Hat
18" × 20"
Roberta Carter Clark
Oil on canvas

Demonstration: Imprimatura Technique

In this demonstration, begin with an underpainting of raw umber. Study your subject, locating masses of light and dark, then do a value painting in this same earth color. Allow this painting to dry. Now let's add color.

Preparing the Color

Set up a palette with lemon yellow, yellow ochre, cadmium red light, alizarin crimson, Venetian red, raw sienna, burnt sienna, cobalt blue, ultramarine blue, viridian and burnt umber.

When the underpainting is dry, pour out about a teaspoon of Liquin, and with a no. 8 brush, brush the medium over the portrait. Then wipe most of the medium off the panel with a clean, dry paper towel. This sheer glaze of medium will allow the new paint to blend more easily into the old; it will also bring the dry paint up to its original intensity, since all oil paint looks duller when it dries.

Painting the Lights

We now begin with the light areas. (The dark areas — the shadows — are already there in raw umber.) Mix three values for the lights you see on the model. For example: white with raw sienna and just a touch of Venetian red; white with less raw sienna and a bit more Venetian red; white plus Venetian red with a touch of cobalt blue (cooler); or white plus raw sienna with a touch of cobalt blue (cooler). Lay the mixtures where you see them with a no. 6 bristle brush.

Painting the Halftones

Now go to the halftones. These are cooler hues on the forehead and chin bands, warmer hues on the cheek-nose band.

Scumble these transition tones on with opaque or semiopaque paint. To scumble, hold the bristle brush so that you are painting with its flat side, and

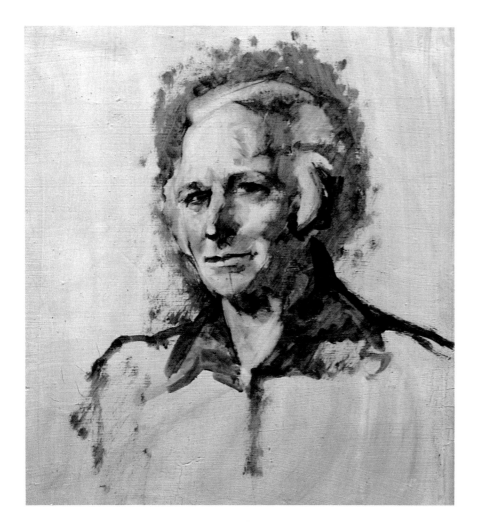

Step 1. *The smooth side of the ¼"-Masonite panel has received two coats of acrylic gesso — one coat north to south, one coat east to west — applied with a 3-inch housepainting brush, and has been allowed to dry. With a crumpled paper towel, a thinned raw umber imprimatura has been applied.*

The head was drawn with no. 4 and no. 6 bristle brushes, a no. 3 round synthetic brush, and raw umber thinned with retouch varnish; it has been applied thinly in the shadows to maintain their transparency.

drag the paint lightly across the surface, creating a broken-color effect.

Hair and Background

Mix a dark, a light, and a midtone color for the hair, saving the highlights for last. Keep the edges soft around the face. There is often a slightly blue halftone where the hair begins to grow at the forehead.

Before you finish the hair shape, work on the background near the head so the hair edges can be painted over the background wet-in-wet, blending the hair color into it in two or three places. Paint the entire background, trying to keep the color to two values.

Defining the Features

Remember that all the openings in the head are *warm*—nostrils, eyes (tear ducts), mouth, ears—and don't make the whites of the eyes really white; study them carefully, squinting hard, and gray them.

Add the dark accents where you see them: the pupils in the eyes, under the collar, wherever no light can get. Now the process is one of going back again and again, refining each feature and the way it relates to the others and to the entire head. If you can't figure out what's wrong, take the portrait off the easel and prop it up against the stool or model stand at the model's feet.

Study the model and portrait, then return the painting to the easel and correct it.

Move down the face from the forehead to the warmer cheek-and-nose area, then proceed to the cooler chin and neck.

Work out the light-and-shadow patterns on the clothing, if you haven't already done so. The clothing is *easy* compared to the head.

Shadows and Reflected Light

By now you may feel that the raw umber shadow area is out of key with the lights and halftones. The shadows should be applied thinly in contrast to

Step 2. *Flesh tones are laid in, mixed from combinations of titanium white, raw sienna, Venetian red, burnt sienna and cobalt blue. Roberta Carter Clark comments on her painting at this stage: "I like parts of the portrait such as the light on the lower lid of the right eye, the form of the nose becoming evident, the cool variations in the lower third of the face. The ugly gray background has got to go; I know I was just rushing and put in any color in the right value so I could play the light hair against it. And the color on the neck is just* raw."

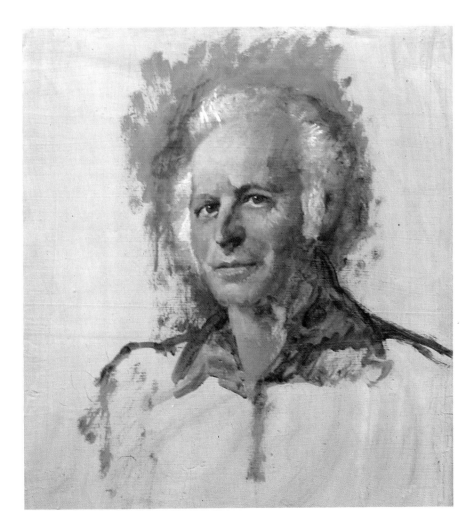

the more heavily painted lights. Scumble the color on in the shadows, allowing the ground to show through. This gives us the transparent glow. Don't paint color indiscriminately all over the raw umber shadow, but only where you feel it's needed to give the portrait head more solidity.

You may see a reflected light at chin and cheek and jawline on the shadow side. Cobalt blue with a small amount of white and raw sienna makes a good reflected-light color. Just remember that the reflected light can never be as light as the halftones. It belongs to the *shadow*. The shadow under the lower lip can use a touch of a *subtle* green.

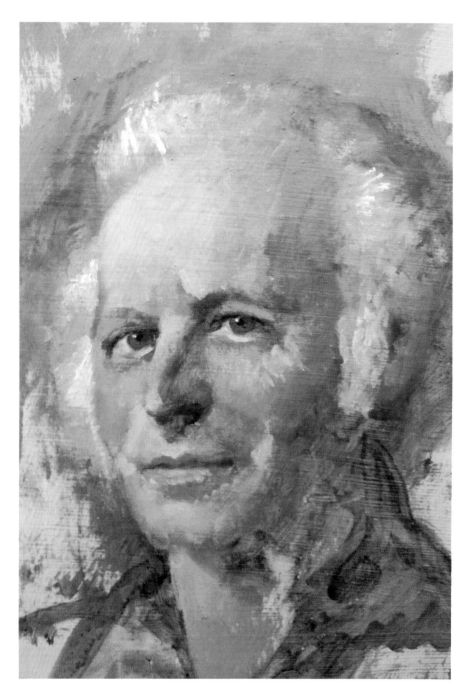

Detail. *This detail of Step 2 allows you to see the brushstrokes better, both in the gesso ground and in the superimposed oil mixtures. Much of the original raw umber is still visible, for example, in the nose, under the nose and on the shadow side of the face. His left temple is defined with a cool, semitransparent scumble of broken color, allowing some raw umber to show through.*

The hair near the face is lighter than the flesh colors. The roundness of the dome of the forehead is conveyed by the cooler halftones carrying the form back to the hairline.

Finishing Up

Study the portrait from a distance, and restate your highlights and accents. Then call it finished. Allow it to dry; this should take at least two to three days. This portrait should have taken approximately four hours divided into two sittings: two hours for the monochrome underpainting, and two hours for the color overpainting. You will find your own best painting schedule, but don't work too many hours at one time.

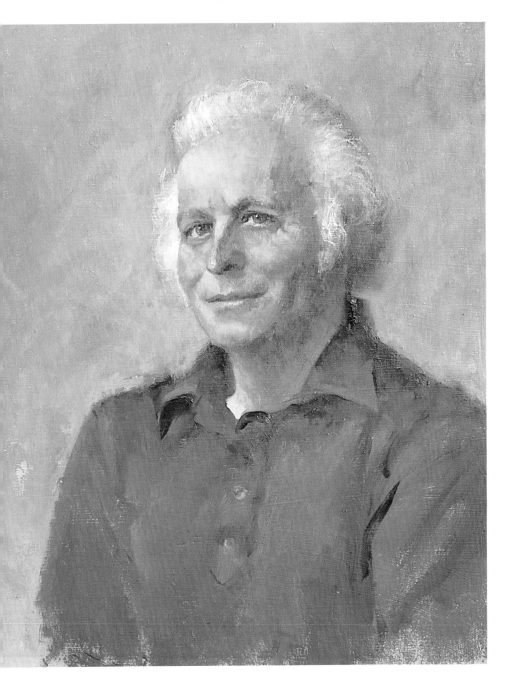

Tony
24" × 30"
Roberta Carter Clark
Oil on panel

Finish. *This is the second sitting for Tony. Every part of the portrait has been refined. Tony's complexion is on the olive side, so it would not do to use warm, ruddy colors in the flesh. However, without warmth, a portrait lacks life; therefore, some warms are concentrated around the eyelids, the end of the nose, the wing at the nostril, and the lips. Tony's shirt is a cool, low-intensity red. A brilliant red would have made Tony's skin look green-gray. White, alizarin crimson, burnt sienna and cobalt blue were used in mixing the shirt color; they were repeated everywhere in the head and in the background in varying values and intensities to give the portrait unity of color.*

You can see the two dark marks where the left sleeve folds against the body of the shirt. These were dashed in, not incorporated into the forms beneath them, so they really pop out.

Portrait Techniques to Try

The best way to begin to paint people is to start with the basics. Get someone to pose for you. Have him sit or stand under a good light, and then paint a series of studies using different approaches. Start off with just basic tonal drawings. Then, using a dark-gray color with white, paint some tonal-painting studies. Next, select a warm color and a cool color and do color-temperature paintings. After practice with some basic painting techniques, start working with full color, but don't forget what you were doing with the tonal-value and color-temperature studies. Remember, they are the basis for controlled color use and should be practiced often.

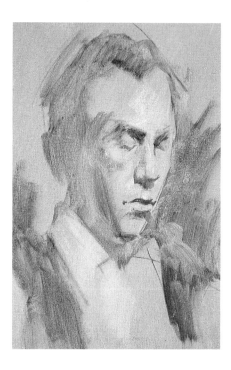

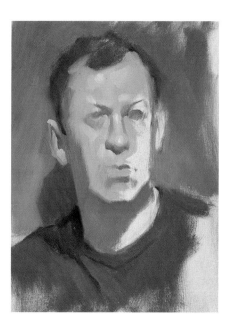

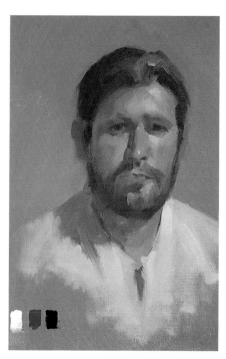

Project. Using a warm gray color and only paint thinner, paint a tonal drawing from life. Start with a toned canvas or panel. Paint in some of the basic lines and dark shapes, wipe out the lights, and refine edges by rubbing or brushing them back in. Draw with tonal shapes and edges. Don't use any white. To lighten a darker value, just rub it with a rag.

Project. Do a tonal drawing, then mix up five values by adding white to lighten values. Start brushing in the correct values of paint, matching them against the tonal drawing. At the beginning, block in only the important basic values. Later, refine edges so form begins to emerge.

Project. Paint a two-color value-and-temperature study. Select a warm color and a cool color, like terra rosa and ultramarine blue, for instance, and block in your painting as practiced in the tonal-painting study. Squint to see value and color relationships.

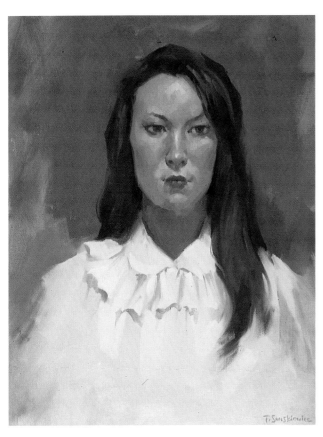

Colleen
16" × 20"
Ted Smuskiewicz

Project. *Have someone pose wearing something interesting but simple. Work on a good block-in of the clothing, starting with darks and lights and maintaining good edge control. Use a closely related color harmony in the painting.*

Try another pose using full color. Work under a different light, perhaps daylight coming from a window. Keep your brushwork somewhat loose and simple. However, try to get a good effect of light by using good tonal values and color.

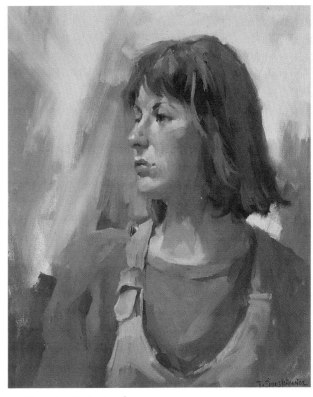

Pam
16" × 20"
Ted Smuskiewicz

Summer Fun
9" × 12"
Ted Smuskiewicz

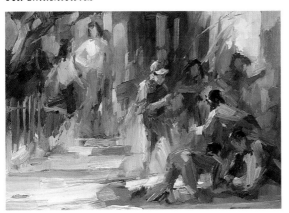

Project. *Try working up a painting from imagination with figures in it. Pick a subject and work out a composition in dark and light values as discussed earlier. Don't just copy a photograph. Use only two colors and concentrate on a good effect of light with color temperature. This painting was done in burnt sienna and ivory black. Try not to be too detailed; go for action and feeling with your figures. Use a brush or painting knife, and try something different in your strokes.*

The Vignette

One of the most useful compositional formats for painting the figure is the vignette. A *vignette* is a picture in which the focal point or area of interest is located more or less in the center of the design and the surrounding space faces off at the edges. A vignette has no definite border. It's a natural composition for a painting that emphasizes the head and facial features. Since the viewer's eye is naturally drawn to the center of a composition and is also attracted to faces in a painting, placing the head near the center produces an almost irresistible attraction for the eye.

When you create a vignette, be careful not to place the head or face in the exact center of the canvas. Instead, the face should be placed slightly above or to one side of the center. If it is a three-quarter view, leave a bit more space on the side to which the figure is looking. It's oddly disconcerting to the viewer for a figure to appear to be eyeing the frame around it!

When planning a vignette, think about which of the model's features you would like to showcase. *Bonnie's Girl in Profile* focuses on the model's unique, high cheekbones, as well as one shoulder. The satin ribbon on her shoulder first catches the viewer's eye.

The thin, straight hair is lost in the background, except for a few strands that fall over her slender neck and shoulder, there again vignetting everything but the focal area where the satin strap catches the light.

Gunnar is 100 percent Swedish. Although he was great as a model, he was definitely not a typical Western subject. Nor was he a large man. The vignette helped keep that a secret. Remember that a vignette focuses attention on the face.

In my third example of a vignette, *Old Lady in a Bonnet*, the facial features are again emphasized. Painting the bonnet with the same values and hue as the background frames the face effectively. Almost all the warm hues are skin tones, which contrast with the cool blue-grays of the bonnet and background. The warm skin tones also add emphasis, contributing to the strength of the face.

The entire canvas was coated with an oil wash of blue-violet grays, modeling a bit of soft pink into the cool blue. The fleshtones were more yellow than pink, so the yellow-orange fleshtones worked as the complement. Some of the fleshtone was also used in the background to make a neutral gray in the vignetted area. Cerulean blue and white in the background were used to define the features.

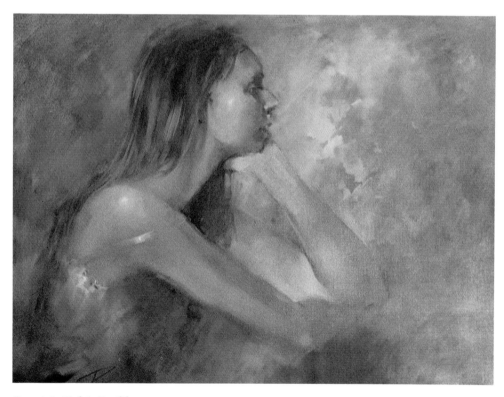

Bonnie's Girl in Profile
24" × 30"
Joyce Pike
Oil on canvas

Red-orange keeps the fleshtones warm, giving more drama to Gunnar's beautiful white hair and mustache. The blue-green complement is used in the reflected lights in the face, shirt and hair. This is a good example of not painting the fleshtones as you see them. Flesh is not always a pink-gray; it can be done with any color on your palette. Notice how little of the face is in light and how much color was used. The soft blue shirt quiets the strong red-oranges.

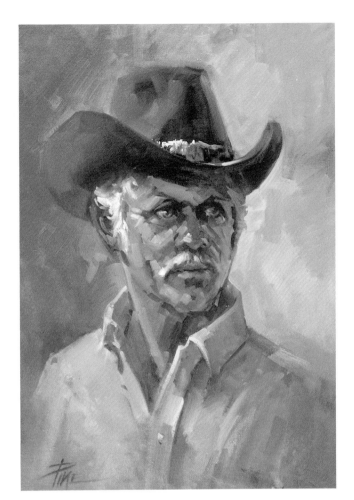

Gunnar
24″ × 18″
Joyce Pike
Oil on canvas

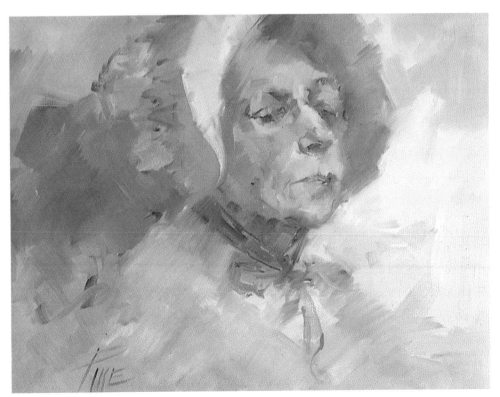

Old Lady in a Bonnet
124″ × 18″
Joyce Pike
Oil on canvas

This model has a thin, exaggerated bone structure. Showing more emphasis on a nose or mouth can be far more exciting than always painting the model with large staring eyes.

Quick Studies

One of the best ways to master painting the face and head is to do a series of quick portrait studies of anybody who is willing to sit for you. Use your family as practice subjects; they're often easily persuaded—and if not, maybe they can be bribed. Quick studies are great practice for painting children—they don't sit still for anything else! The quick study is not an elaborate or highly finished portrait. Instead, it's a less formal, more relaxed attempt at painting in a direct, unlabored manner.

The purpose of doing quick studies is not to see how quickly you can make the portrait look like the person you're painting. The purpose is mastery of the basic procedure—what to think about and when. There are many steps to follow before the problem of likeness should be considered.

For instance, check to see if the light is correct. Try a light stand with a 100-watt daylight flood lamp at the correct distance and angle to give the cast shadow under the nose the desired length. Adjust the light until you find its best placement on your subject. Cool light bulbs are available if you wish to simulate north light.

Check your model carefully for a relaxed, well-planned pose. Have your

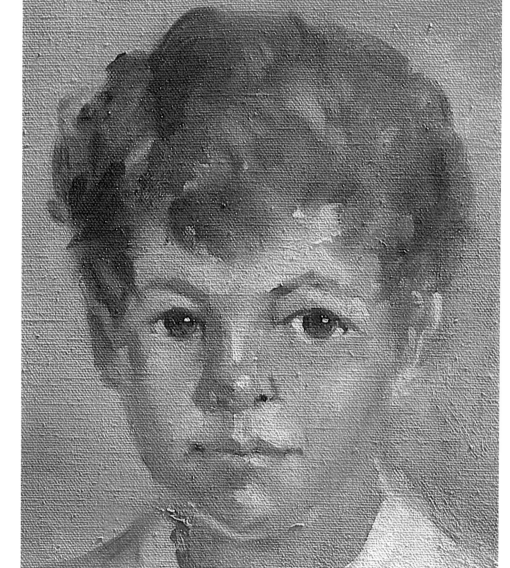

Ricky
12″ × 9″
Joyce Pike

Using a front view is much easier if your model moves, because you can work the conventional feature placement on the oval of the face. If your model is young, it is better not to make him, or yourself, frustrated by choosing a difficult pose, such as a three-quarter view or profile.

An oval was drawn on blue-violet, oil-toned canvas, and the eyes, nose and mouth were placed before Ricky began to pose. Three pots of paint were premixed: light, midtone and dark flesh-tones as close to Ricky's coloring as possible.

All light areas were covered with the midtone flesh mixture; then quickly the dark areas such as eye sockets, nose shadow and shadow areas on the face and neck were placed.

Then the light areas of the face were painted with the light flesh mixture.

model twist and turn in several directions until you and your model agree on a good, comfortable pose. Even if you plan on doing only a head study, turn or move the head in several directions before settling on a pose.

Decide which technique you plan to work in and cover your canvas with a toning. Now you're ready to begin the business of painting. When doing practice subjects, it's good to emphasize bone structure. You can always soften an edge later if it seems too harsh. Think of your model as planes, never as a person, or you will tend to get hung up on likeness. The likeness will be there if the color and structure are correct.

Sculpt each separate plane, creating form where none existed. Once you have established the forms of the facial features, start to make the study become an individual.

Consider the hair as a single shape, never as individual strands. The overall pattern of lights and darks, if properly placed, will be all that's needed to describe the hair convincingly.

After the form has been modeled and harsh brushstrokes softened, place highlights on the face, hair or wherever they appear.

Jason
12″ × 9″
Joyce Pike

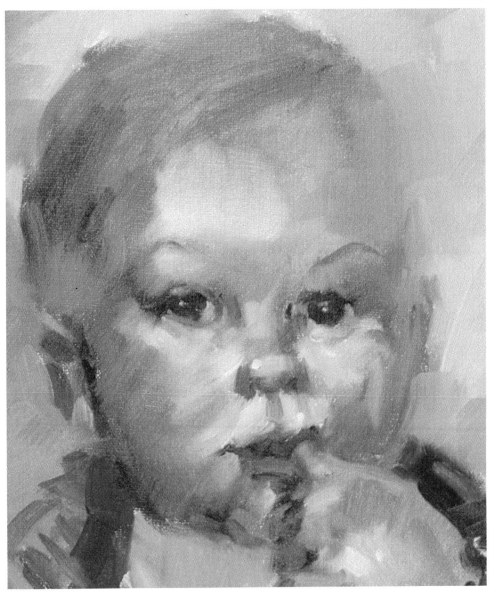

The trick of painting from a photo is to plan a skull structure first before relying on the photo. It helps avoid a photographic look. Staying loose also makes it look like a painting from life rather than a copy from a photo. This quick sketch took less than one hour, yet made a complete statement.

When you're doing a quick sketch, don't keep messing around with it until it's past repair. This is one point where you may go wrong.

INDEX

METRIC CONVERSION CHART		
TO CONVERT	**TO**	**MULTIPLY BY**
Inches	Centimeters	2.54
Centimeters	Inches	0.4
Feet	Centimeters	30.5
Centimeters	Feet	0.03
Yards	Meters	0.9
Meters	Yards	1.1
Sq. Inches	Sq. Centimeters	6.45
Sq. Centimeters	Sq. Inches	0.16
Sq. Feet	Sq. Meters	0.09
Sq. Meters	Sq. Feet	10.8
Sq. Yards	Sq. Meters	0.8
Sq. Meters	Sq. Yards	1.2
Pounds	Kilograms	0.45
Kilograms	Pounds	2.2
Ounces	Grams	28.4
Grams	Ounces	0.04

Improve your skills, learn a new technique, with these additional books from North Light